Pictish and Viking-Age Carvings from Shetland

Ian G Scott and Anna Ritchie

Royal Commission on the Ancient and Historical Monuments of Scotland

Published in 2009 by The Royal Commission on the Ancient and Historical Monuments of Scotland.

British Library cataloguing in Publication Data:
A CIP catalogue record for this book is available on request from the British Library.

All rights reserved. No part of this publication may be reproduced or transmitted in any form or by any means, electronic or mechanical, without permission in writing from the publishers.

Crown Copyright © RCAHMS 2009
ISBN: 978 1 902419 63 3

Printed by Barr Printers, Scotland

For over 100 years RCAHMS has been recording and surveying our archaeological, architectural and industrial heritage, creating Scotland's National Collection of materials and information on the historic and built environment. Including one of the world's largest and most important aerial photographic archives – made up of over 1.6 million images of Scotland, and over 10 million military reconnaissance images from across the globe – and some 3 million drawings, prints, maps, manuscripts and photographs, RCAHMS collections are an internationally important resource, helping to connect people to places across time.

Our archive material is made widely available through publications, interactive online collections, major exhibitions held at venues across the country, and via a public search room at the RCAHMS premises in Edinburgh.

Search our databases online: rcahms.gov.uk

The Royal Commission on the Ancient and Historical Monuments of Scotland (RCAHMS)
John Sinclair House
16 Bernard Terrace, Edinburgh EH8 9NX
0131 662 1456
rcahms.gov.uk
Registered Charity SC026749

Front cover: Hooded figurine from Scalloway. (Photograph courtesy of Niall Sharples) SC1132397

Back cover: St Ninian's Isle and the south-west coast of Shetland. SC1132398

Contents

Acknowledgements	iv
Introduction	v
Pictish Shetland	v
Early Christianity in Shetland	vi
Norse Shetland	vii
Carved Stones	1
Drawings of Carved Stones	11
Pictish Symbol Stones	12
Pictish Stone Discs and other Small Artefacts	14
Early Christian Cross-slab from Papil	18
Early Christian Stone Shrines	18
Ogham Inscriptions	27
Early Christian Cross-slab from Bressay	28
Early Christian Cross-marked Slabs	29
Runic Inscriptions	34
Cruciform Stones	36
Relief Crosses	43
Hogback and Recumbent Monuments	44
Curiosities	45
Summary Catalogue and Concordance	47
References	55
Index	58

Acknowledgements

The authors are indebted for help and information to Tommy Watt, Ian Tait, Jenny Murray, Carol Christianson, John Hunter and Brian Smith (Shetland Museum and Archives); Val Turner and Jimmy Moncrieffe of the Shetland Amenity Trust; David Clarke, Andrew Heald and Fraser Hunter of the National Museums of Scotland; Iain Fraser of the Royal Commission on the Ancient and Historical Monuments of Scotland; Steve Dockrill, Alastair Mack, Rachel Barrowman and Isabel Henderson. We are indebted to Ian Fisher for his work on cruciform stones, to Michael Barnes and Roy Page for their work on runic inscriptions and to Katherine Forsyth for her work and advice on ogham inscriptions, on all of which we have relied heavily. We are particularly grateful to Pauline Scott for assistance and moral support.

Ian Scott wishes to thank the Shetland Islands Council, RCAHMS, and especially the Hunter Archaeological Trust for financial support and encouragement during his retirement.

We are very grateful to Jack Stevenson, Oliver Brookes and Alasdair Burns for their patience and expertise during the production of this volume.

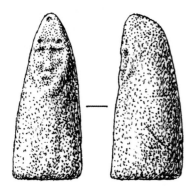

Hooded figurine from Scalloway, no.15. Excavated from outside a broch, this sinister little figure may have been used in some pagan ritual. (see p15) 1:1 SC1134040

Introduction

On Tuesday 12 July 1774, a minister named George Low arrived in Sandness in the west of mainland Shetland. He was engaged in a journey of discovery through the Northern Isles and was particularly interested in natural history and antiquities. In Sandness he noticed built into the wall of the church 'a stone carved with several odd figures', and luckily for us he drew it, for the church was later demolished and the stone was lost (no.1). This was in fact the first record in Shetland of a Pictish symbol stone, and two centuries were to pass before another was found.

In use to this day as a stile in the kirkyard wall at Baliasta in Unst is a recumbent gravestone (no.127), which is one of the latest in date of Shetland's early medieval carved stones. These two stones, Sandness and Baliasta, mark both ends of a spectrum which spans Pictish and Norse times in Shetland from about AD 600 to AD 1200. More than a hundred stones are known, some complete and many others only as fragments, and, while many reflect links with Orkney, the Western Isles and mainland Scotland, some are unique in style to Shetland. Only a few stones have come from archaeological excavations, most notably at St Ninian's Isle; many are still in the graveyards for which they were created and a number can be seen in the Shetland Museum in Lerwick and the National Museum of Scotland in Edinburgh. Chance led to the recovery of the Pictish symbol stone from Breck of Hillwell (no.2), which had inadvertently been used to build a drain, and grave-digging has yielded several stones at Mail (nos 5, 6, 51, 53), while the Burra Stone at Papil had become the family grave-marker of a discerning Baptist missionary in the nineteenth century (no.29).

Pictish Shetland

From the sixth to the ninth centuries, most of mainland Scotland was the kingdom of the Picts, and, although we cannot be sure of their political status, the Western and Northern Isles were culturally Pictish in the sense that they shared the same traditions and artefacts. The excavated remains of curvilinear Pictish houses can still be seen outside the brochs at Old Scatness and Jarlshof in southern Shetland, and Old Scatness yielded a charming Pictish carving of a bear, while from Mail, a little farther north, came a superb incised carving of a wolf-man (nos 7 & 6). Distinctively Pictish are the symbols that were carved both on upright monuments and on small stone discs, the latter of which are unique to Shetland (nos 16–28). A standard range of symbols was used throughout mainland Pictland and the islands, of which some are abstract designs and others are realistic depictions of animals and objects, and the rectangle symbol (as seen on no.1 from Sandness) seems to have been a favourite in Shetland. Many theories have been suggested to explain Pictish symbols, but, in the absence of contemporary written documents, none can be proven (and the names of the individual symbols are modern). It seems likely that many symbol stones were grave-markers and that the symbols somehow identified the deceased, while other stones may have been territorial boundary markers. Symbols on small artefacts such as stone discs may have identified their owners, though it may be noted that no symbols appear on another class of small Pictish artefact, painted pebbles. Symbols may also have been used on wooden or textile objects which have not survived the centuries.

Pictish symbols were carved on Christian cross-slabs as well, alongside but never on the cross itself, and it is thus clear that the symbols were tolerated by the Church. The earliest surviving use of symbols can be dated to the sixth century and they continued into the ninth and possibly into the tenth century. Particularly interesting is the discovery at Mail in 2008 of a fragment of a slab bearing a double-disc and Z-rod symbol in which the discs are decorated with cruciform designs, for it raises

the possibility that here, uniquely, is a physical combination of Pictish symbol and Christian cross (no.5). There seems, however, to have been a taste in Shetland for cruciform designs within circles, as demonstrated on the back of the Bressay cross-slab (no.54), in decoration on stone discs and on silver bowls from the St Ninian's Isle treasure; a Christian attribution seems unlikely (Ritchie 2008).

Early Christianity in Shetland

Irish missionaries, or possibly Pictish monks trained in Ireland or Iona, were responsible for the conversion of the Northern Isles to Christianity, which was probably a very gradual process and may not have begun until the eighth century. They also brought literacy in the form not simply of Latin but also of the Irish ogham script, which is found incised on stones, usually grave-markers and mostly in Irish Gaelic. Once the Church was established, it had at least two flourishing centres at Papil in West Burra and at St Ninian's Isle, at both of which sites an extraordinary number of parts of stone shrines have been recovered. This evidence for the use of shrines links Shetland with sites farther south, such as the monasteries at Iona in Argyll, Tarbat in Easter Ross and St Andrews in Fife, where shrine parts have also been found. The dedications to St Ninian and at West Burra to St Laurence are probably no earlier than the twelfth century, but the sculpture is evidence of the presence of churches in the eighth or ninth centuries, and traces of the early church and of early burials have been found during excavations on St Ninian's Isle. Most of the surviving ruins of churches date to no earlier than the twelfth century, and sadly there are no extant examples of the 'steeple kirks' that were formerly such a distinctive component of the Shetland landscape. These were churches with tall round towers attached to their west walls, which are known to have existed in Shetland at Ireland, Tingwall and Papil (a single example survives to this day in Orkney, at St Magnus' Church in Egilsay).

The name Papil is derived from Old Norse *papar*, meaning priest, and there are at least seven other *papar* names in Shetland, all island names or locations on the coast and usually on fertile land. These are places which the incoming Norse settlers associated with Christian clergy, and they are pointers towards the location of pre-Norse church foundations, although as yet only Papil in West Burra has produced tangible evidence in the form of Early Christian carved stones (there are, however, *papar* placenames close to other sites with stones, such as Tresta in Fetlar and Gungstie in Noss). It was secular wealth and social standing that required elaborate monuments such as the Papil and Bressay cross-slabs, while small monastic sites may not have had such patrons. Another factor was the availability of suitable stone, the best of which for carving in relief was the sandstone of western and south-eastern Mainland, while fine-grained schist or slate was sometimes preferred for incised work, where the freshly carved motifs stood out much paler than their background. The stone of choice could be imported from elsewhere: despite the fact that the island of Bressay consists of sandstone, the cross-slab from Culbinsburgh was made of schist imported from western Mainland, while the Papil cross-slab from the schist-based island of West Burra was made of sandstone imported from eastern Mainland. Steatite is even easier to sculpt when fresh than sandstone but it is more difficult to achieve the large thin slabs required for cross-slabs.

It is curious that there is as yet no early carved stone from Fair Isle, so conveniently placed between the two island groups of Shetland and Orkney, and indeed used in Norse times for a fire beacon to warn of sea traffic between the two. Remote communities often retain old traditions, and it may be that Christianity was slow to be accepted in Fair Isle. The strength of Pictish cultural tradition in Orkney may be gauged by the discovery there of eleven intact or fragmentary symbol stones, as well as small artefacts bearing symbols and extensive evidence for domestic settlements of Pictish date. As yet, however, there is no certain example from Orkney of a symbol-bearing cross-slab or of a stone shrine, and there appears to have been a hiatus in stone carving there in the ninth century, which is perhaps attributable to the strength of Viking activity.

Not included here, but part of the Pictish heritage in Shetland, is a remarkable collection of lightly incised graffiti on small pieces of slate, which were found during excavations at Jarlshof. They include fine portraits of a young man and an old man, boats, a cross decorated with spirals and motif-pieces for practising decorative carving, and although they were found mostly in the early

Viking-age levels of the settlement they are likely to have been the work of Picts. This attribution is supported by a smaller assemblage of graffiti from the Pictish levels at nearby Old Scatness.

Norse Shetland

Viking raiders in longships sailed from the west coast of Norway to Shetland from the eighth century onwards, but sometime after AD 800 they were supplemented by parties of colonists who came to stay. The treasure of Pictish silver from St Ninian's Isle is probably evidence of local wealth hidden to evade Viking raiders, although it could have been plunder from Viking expeditions farther south that was buried to keep it out of the hands of other Vikings. It was buried beneath an incised cross-slab (no.66) in the paved floor of the chapel.

The Norwegian settlers brought a new language, known to us as Old Norse, and a new form of writing, the runic script, which like ogham was ideal for amateur carving in stone. Many of the place-names in modern Shetland can be traced back to Old Norse origins, and it is clear that the older Pictish language was quickly replaced by that of the new settlers. Their rectangular houses can be seen at Jarlshof, where a successful farm was occupied over some three centuries, and there are also fine examples of excavated Norse houses to be found in Unst at Belmont, Underhoull, Hamar, Sandwick and elsewhere.

The Norsemen began to adopt Christianity in the tenth century, and an elaborately carved cross-slab from Culbinsburgh in Bressay displays an ogham inscription with a linguistic mixture of Gaelic and Old Norse (no.54). Simple cross-marked slabs are difficult to date and may be Pictish or Norse in date, while the cruciform stones still to be seen in graveyards in Yell and Unst have counterparts in Norway and are likely to belong to Norse Christian burials (nos 81–123).

A distinctive recumbent form of grave monument was invented in Anglo-Scandinavian Yorkshire in the tenth century, which has a convex top and sloping sides and is known as a hogback. This fashion spread into southern and eastern Scotland, and thence into the Northern Isles, with a single example in Shetland from St Ninian's Isle (no.126). It is unusually small and may have marked a child's grave of the eleventh century.

The flattened ridge of this stone relates it to the 'keeled stones' or recumbent monuments of the twelfth century in Shetland, such as Baliasta (no.127) and the later examples at Framgord (Sandwick) in Unst. The graves marked by these stones were in burial grounds associated with small stone churches or chapels, remains of which can be seen at St Ninian's Isle and Framgord. Some were built initially as chapels for leading Norse family estates, but they were re-organised into the parish system in the twelfth century. There are traces of Norse long houses close to the Framgord burial ground, as well as an excavated late Norse house a short distance away on the foreshore of Sandwick Bay.

Pictish and Viking-Age Carvings from Shetland

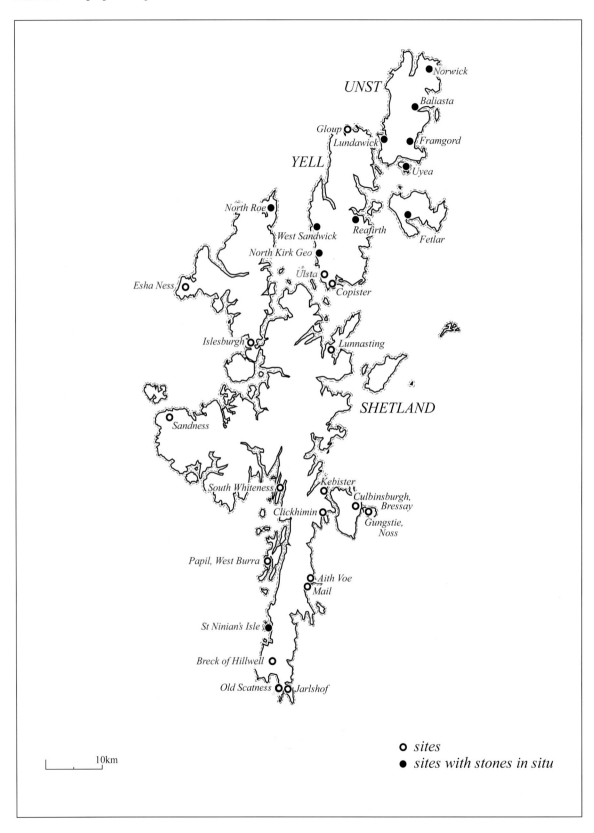

Carved Stones

All the known carved stones dating to before AD 1200 from Shetland have been drawn, including lost stones where there are extant early drawings, except for two cross-incised stones found in Fetlar in 2001 which we have been unable to trace. The widespread distribution of the stones is shown opposite.

Pictish Symbol Stones

The stone from Sandness, Walls (no.1) is now lost and its original location uncertain, but this was a 'classic' Pictish symbol stone with three incised symbols known as the mirror, horseshoe (or arch) and rectangle.

Found covering a field drain, the surface of the slab from Breck of Hillwell, Dunrossness (no.2), is badly flaked, but there are traces of crescent and rectangle symbols towards the base of the stone and a possible disc above them. No.4 was found in the small island of Uyea off the south coast of Unst, and the design on no.4 may be part of another rectangle symbol. Despite being carved on both faces, nos 3 and 4 are unusually thin at 30–35mm thick and may have belonged to relatively small grave-markers. There is reason to believe that no.3 came from Papil, Yell.

Grave-digging in modern times in the churchyard at Mail in Cunningsburgh, Dunrossness, has brought to light several carved stones. One is a fragment of a dressed slab, possibly a cross-slab. It is decorated on one face only with panels enclosing interlace and a double-disc and Z-rod symbol (no.5). The discs contain cruciform designs. A graffito between the bar of the double-disc and the upper arm of the Z-rod reads '1769' and may have

Map showing the original locations of monumental carved stones in Shetland, which were widespread throughout the islands, particularly in coastal locations. GV004558

been added when the fragment was first discovered or when it was thrown into the bottom of a newly dug grave. Like the Breck of Hillwell symbol stone (no.2), the symbols on this slab appear to have been carved beneath other designs, and the interlace panel may have been part of the base of a Christian cross. Again from the Mail churchyard, another slab (no.6) bears a lightly incised 'formidable man' symbol. The figure carries a club and an axe and either wears a wolf-mask (perhaps a pagan priest) or portrays a mythological wolf-man, and its oval eye is particularly typical of Pictish art. The tunic has a decorated hem, perhaps a woven braid or an embroidered strip, and the handle or shaft of the axe is very long and thin and may represent an iron, rather than a wooden, shaft.

Cunningsburgh is a fertile area with a sheltered natural harbour at Aith Voe, and there are steatite quarries along the Catpund Burn that are known to have been in use from prehistoric times into the Norse period. The Scandinavian placename Cunningsburgh means 'king's fort', and it seems likely that this area was a power-centre in Pictish times. A number of carved stones have been found in or around the graveyard at Mail, including ogham and runic inscriptions (nos 5, 6, 50, 51, 53, 76), and two more runic inscriptions came from the west side of Aith Voe (nos 73 & 74). The graveyard clearly lies on top of earlier domestic settlement, probably related to the site of a broch on an adjacent tidal islet that was formerly part of the same promontory and from which came a small hooded figurine of Pictish date (no.14). Two of the ogham inscriptions and the 'formidable man' carving probably belong to a Pictish phase of occupation on this centuries-old village, whereas the fragment with the double-disc and Z-rod symbol may have come from the burial ground of an adjacent early chapel. Late Viking-age activity on the site is indicated not only

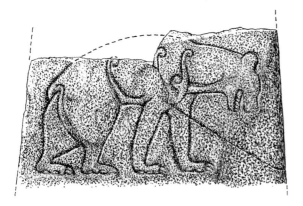

This carving of a menacing bear is an outstanding example of the stonecarver's skill: Old Scatness, no.7. 1:5 SC1132401

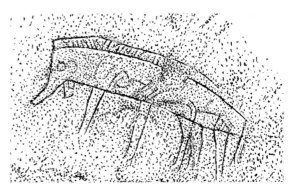

In contrast to the bear on the left, the boar is a poor rendering of the animal: Old Scatness, no.9. 1:2 SC961062

by the runic inscriptions but also by the discovery in 1993 of a bone comb of late Norse type.

The imposing Iron Age settlement at Old Scatness, Sumburgh, has yielded four small carved stones of varying degrees of informality and quality of workmanship. The bear (no.7) is an exquisite and life-like rendering of the animal, with typical Pictish scroll-joints, whereas the boar (no.9) is a poor effort with too many legs. Yet the boar would have been a far more familiar animal, for there were no native bears in the Northern Isles, and the bear may have been copied from some exotic object imported from Scandinavia or Europe. The fish (no.8) is small and damaged but was probably a good example of a salmon.

Old Scatness is a remarkably well-preserved settlement that has a broch surrounded by domestic buildings, and the whole complex was meticulously excavated by Steve Dockrill and his team from the University of Bradford from 1995 until 2007. The site lies close to the east shore of Quandale Bay at the southern end of Shetland, less than a mile from the contemporary settlement at Jarlshof. The later houses belong to the early Pictish period in the sixth and seventh centuries, and it was from these small cellular buildings that the carvings came, along with other Pictish artefacts. The boar was built into the stone kerb of a hearth, while the glorious bear is thought to have adorned an internal wall in one of the houses, and the choice of two such ferocious animals in a domestic context is interesting in itself. The bear may be a re-used fragment of a larger monument that may have borne other, now lost, ornament, for its width is similar to that of the symbol stones from Sandness and Breck of Hillwell (nos 1 & 2).

An unusual carved stone from Shetland is the slab bearing two footprints at Clickhimin in Lerwick (no.10), and it can be matched by a stone in Orkney at St Mary's Kirk, Burwick, South Ronaldsay, which is also carved with two footprints. In both cases the footprints are shod in the sense that no toes are shown, and they are carved as shallow hollows rather than incised outlines. The Clickhimin stone is now set in the threshold of the outer gateway to the site, but this is unlikely to have been its original position. Footmarked stones are known from elsewhere in Scotland and in Ireland, notably at the Dalriadic fort at Dunadd in Argyll, and they seem to have been used in royal inaugural ceremonies in early medieval times. It is possible that Clickhimin was a Pictish inaugural site, particularly as the broch settlement was clearly of high status in earlier Iron Age times. Near Breckon in north Yell there was formerly a slab with a single footprint (now lost), which was known as the 'Wartie', because it was believed that standing in rainwater in the footprint would cure warts.

Pictish Stone Discs and other Small Artefacts

Again from Old Scatness, the crescent and V-rod on pebble (no.11) appears to be a hasty graffito. With a little imagination the design on the reverse might be seen as a whale or a boat. There can be no doubt that the small pebble from Kebister (no.12) carved

with a cross is a Christian amulet, the circle at the base of the cross perhaps representing a circular cross-base such as the millstones that were used at Iona. Similar amulets have been found in Ireland and the Isle of Man. A delightful small figurine of a bird at rest (no.13) resembles a puffin and was perhaps carved as a toy for a child or as a totemic amulet. Two hooded figures (nos 14 & 15) look like chessmen, but chess was not introduced until the twelfth century and these are Pictish in date. Pictish and Viking board games involved a king and his warriors, for which these sinister figures would not appear to be appropriate. They are more reminiscent of the *genii cucullati* or cloaked deities of Roman times, and it seems possible that they were votive items used for pagan religious or healing purposes (no.14 came from Mail and no.15 from Scalloway, both of which are broch sites with later Pictish activity). The two figures differ in detail: on the Scalloway piece the face is sunk within its hood, whereas the Mail face protrudes from its hood, and the Scalloway face has a panel with three holes above the brow which implies that there was originally a small decorative plate set into the panel. The Scalloway piece is also coated with a manganese-rich material, which makes it dark brown in colour. These three items are unusual amongst surviving Pictish stone carving in being sculpted in the round, though bird, animal and human heads appear in the round in metalwork and bonework.

Unique to Shetland is a series of decorated stone discs, around 50–75mm in diameter, some of which are well-crafted, like the S-spirals on no.16, the triscele on no.21 and the rectangle on no.24, whereas others verge on the crude, such as the ship-carving on no.19. Outside Shetland, a single decorated disc has been found at Stemster in Caithness, and it may have originated in Shetland. Most discs are made of sandstone but steatite was also used (no.22 from Gletness is steatite). These discs are probably too big to have been playing pieces and may have been personal amulets or part of the equipment of shaman-like healers. Their decoration is often more formal on one side than on the other. Two discs (nos 17 & 21) are carved with distinctively Pictish symbols, in both cases the double-disc and Z-rod that seems to have been especially relevant to Shetland, though the Z-rod on no.21 is reversed and only one of the discs is decorated. It is almost a cross within a circle, and two opposing quadrants are infilled with dots. This dot decoration links the disc with the bowls in the St Ninian's Isle treasure, and the use of dots (known as *pointillé* decoration) indicates that Shetland craftsmen were familiar with similarly decorated gospel-books. There is also a hint in the arc beneath the right-hand arm of the rod that the symbol may have replaced an earlier carving.

Two discs bear zig-zag decoration (nos 18 & 28) and one has key-pattern (no.26), which are motifs found on the St Ninian's Isle silver sword-chapes, while the S-spirals on nos 16 and 18 are matched on corner-posts nos 31 and 34 from St Ninian's Isle. The incised marine mammal on no.26 might also be seen as a link with St Ninian's Isle, where the treasure was accompanied by part of a porpoise jawbone, as well as with a seal on one of the Jarlshof graffiti. One disc displays a cross within

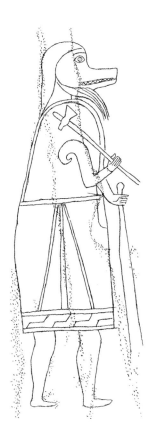

The 'formidable man' from Mail is a rare and detailed depiction of a masked figure, no.6. 1:5 SC961063

a circle (no.27), while the effect of an encircled cross is conveyed by nos 23 and 25, and this is another link with monumental stone carving. All the decorative motifs on the discs are familiar from the Pictish artistic repertoire, and at Jarlshof, where their provenance is known, they belong to the early Pictish phases of the settlement. There may be a failed attempt at an inscription on the edge of disc no.28.

Early Christian Cross-slab from Papil

Known in Shetland as the Burra Stone, this superb cross-slab had been re-used as a grave-cover in the nineteenth century and was sent to Edinburgh in the 1890s (no.29). The sculptor has skilfully combined incision with low relief in the carving on this stone, which was probably created around AD 900. The circular cross-head has neat interlace between its arms, and cowled monks carrying staffs and book satchels (or perhaps reliquaries) flank the shaft of the cross. One of the monks on the shrine panel from Papil (no.30) also has a book satchel, and this important detail appears to be unique to Shetland. The panel forming the rectangular base of the cross encloses a large animal often compared in style to the Lion of St Mark in the illustrated manuscript known as the Book of Durrow, but there are significant differences and the more dog-like Papil beast is perhaps better seen through the eyes of George and Isabel Henderson as akin to 'Cerberus guarding the gate of Hell' and perhaps a latecomer to the Pictish symbol repertoire (2004, 156). Two axe-carrying birdmen beneath this panel have been seen as a later addition to the slab, but the Pictish symbol on the Mail fragment (no.5) appears to be in a similar position at the foot of the main decoration, and the Papil birdmen may have been part of the original design. Despite their tunics, these are not masked men like the Mail figure, for they have clawed feet, and they should probably be seen as devils torturing the human soul represented by the head between their long heron-like beaks.

The long narrow island of West Burra is one of a group of low fertile islands off the west coast of southern Mainland Shetland. Even before the steeple kirk of St Laurence was built in the twelfth century, the island had been chosen as the location for an early Christian monastery, which itself prompted the creation of the name Papil by the incoming Norsemen of the ninth or tenth centuries. Grave-digging in the kirkyard has led to the discovery of parts of three stone box-shrines and three cross-slabs belonging to the early monastery, and the monks depicted on one of the shrines (no.30) and the finest of the cross-slabs (no.29) provide a rare glimpse of monastic life and its accoutrements, with their hooded robes, staffs and book satchels. These monks may have included men trained in Ireland or at Iona, for the free-standing cross carved on no.30 is reminiscent of such monuments in Ireland and Iona, and the round-headed cross-slab (no.59) has a finely carved interlaced cross, which can be matched at the Iona monastery. A simplified version of this interlaced cross was found at Skaill in Orkney (Buteux 1997, 131).

Early Christian Stone Shrines

Shetland has a remarkable number of parts of composite stone shrines, mostly from Papil and St Ninian's Isle. The shrine is effectively a rectangular stone box, constructed with four side panels that slot into corner posts and probably (though none exists) a horizontal slab top to form the top of the box. The idea was almost certainly derived from

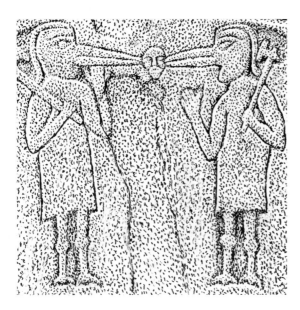

Detail of birdmen on the cross-slab from Papil, West Burra, no.29. Despite its pagan appearance, this image is likely to be Christian in concept and to show devils torturing a human soul. 1:5 SC1133106

wooden prototypes, and these shrines were used to hold relics of the saints, sometimes a few bones or personal belongings, and were placed within the church. They may have stood to one side of the altar or, more likely in these small churches, acted as the altar itself. It is also possible that some were part of a screen between nave and chancel rather than a shrine. A very attractive carved stone from Papil is the figural panel from the side of such a shrine or screen (no.30), and this has been used in the reconstruction drawing of a shrine. Mostly it is the corner posts that survive, sometimes with carved decoration and always with two or more slots to hold the side-panels and a rough base that was sunk into the floor of the church (nos 31–47). A post with three slots, such as no.32 from St Ninian's Isle, indicates a double shrine with an internal subdividing slab. In some cases the post is simply a modified beach pebble of the appropriate elongated shape, and the overlarge base of the Gungstie post (no.46) may imply that it was set in sand and thus required extra support. Sometimes there is a low plain or decorative boss on the top of the post (eg no.32). Not surprisingly, given their bulk, far more posts survive than panels, or even fragments of panels, and those posts that are broken must surely have been damaged deliberately. The fragment no.40 may be part of a panel or screen, as suggested in the drawing, but it is also possible that it is part of a later slab.

A number of posts are decorated on their outward faces with a range of motifs, from groups of small pits (four represent the cross and three the Holy Trinity) to S-spirals (no.31, face *d*), running spirals (no.34 face *b*), paired spirals (no.41) and a triquetra knot (no.31, face *a*) to pairs of S-dragons (no.34 face *a* and no.31 face *a*), which have been interpreted as symbolic guardians of the relics held within. There is considerable variation in the quality of workmanship.

The figural scene on the Papil panel (no.30) shows a procession of monks moving towards a free-standing cross set on a large square base like that depicted on the Papil cross-slab (no.29). These two monuments are likely to have been in contemporary use, the shrine placed within the church and the cross-slab marking the grave of a wealthy patron outside in the burial-ground. Four of the monks are on foot while the fifth, clearly depicted as an older man, rides a sturdy Shetland pony. The old man might perhaps be the saint for whose relics the shrine was created. Charles Thomas suggested that the flowing spirals over which the monks pass may have been intended to be seen as waves of the sea that bore the early missionaries to Shetland (1971, 156). The cross-head bears pairs of spirals, which echo those of the 'waves' and which are also found on shrine posts nos 41 and 44. S-shaped spirals were also favourites in Shetland and appear on shrine post no.31 and two of the small discs (nos 16 & 18).

There appear to be parts of at least two shrines from St Ninian's Isle and three from Papil (Thomas 1973; 1983). Given the space that a shrine would occupy in a small church, it seems likely that at both sites we are looking at the remains of successive rather than contemporary shrines. Even more puzzling is why Shetland should have had so many examples of a type of church furniture that is comparatively rare elsewhere in Scotland.

The delightful St Ninian's Isle is linked today to the south Mainland of Shetland by a natural sand tombola (which is a geological Site of Special Scientific Interest), but in Early Christian times, before the tombola formed, the island was probably accessible only at low tide. The ruins of a twelfth-century chapel were revealed by excavation in the 1950s, and it seems that the chapel had been

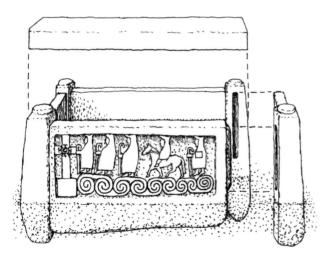

Conjectural reconstruction of a composite stone shrine, showing how the side panels slotted into the corner posts and how the whole shrine would have been sunk into the ground for stability. 1:10 SC1134054

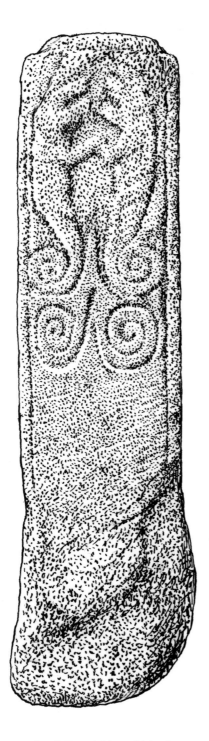

This corner post from St Ninian's Isle, no.34, has been carved with a pair of elegant clasping animals and the popular spiral motif. The raised tenon at the top may have helped to secure the lid of the shrine. 1:5 SC1134057

abandoned in the eighteenth century and left to the encroaching sand. Traces of an earlier chapel were found beneath it, and the famous treasure of Pictish silverwork was discovered in the decayed remains of a wooden box under a broken cross-slab (no.66). There are close links between the decoration on the stone posts and that on the silver bowls in the treasure, for example the swirl on the top of post no.32 and on the base of one of the bowls. Later excavations in 2000 have demonstrated that burials in stone cists (pits lined and covered with stone slabs) were being made around the chapel in late Pictish times, and many grave-markers carved with crosses were found during both campaigns of excavation (Barrowman 2003). The burials included children and probably represent the local population of the time. The fact that the little church was furnished with stone shrines underlines the importance of the site in the eighth and ninth centuries.

Ogham Inscriptions

The ogham alphabet was invented in Ireland in the early centuries AD and brought to Scotland by Irish monks and other Irish settlers from the seventh century onwards. However, most of the Shetland inscriptions are likely to be ninth or tenth century in date and may not have been directly related to Irish influence, as ogham was by then integral to Pictish culture. This late date is interesting in itself, for it implies that the gradual Norse settlement of Shetland did not obliterate the Christian Church. Mostly the Scottish oghams are difficult to transliterate, but they often include personal names and may have been memorial in intent. They use both Irish Gaelic and Pictish Celtic, and their modern transliteration is the work of Katherine Forsyth (1996). There are seven 'monumental' ogham inscriptions from Shetland, from church sites at St Ninian's Isle, Mail in Cunningsburgh, Whiteness and Culbinsburgh in Bressay, and one from a peat bog in Lunnasting (nos 48–54). The fragmentary inscription in bind-oghams from South Whiteness (no.49, IB.256) is carved alongside a panel of double-ribbon interlace and is part of the same monument as fragment ARC 805. This was proved in 2008 when the National Museums of Scotland kindly allowed the fragment in their care to be taken to Lerwick in order to test the

join between the two pieces. One of the fragments from Mail (no.50) has ogham letters on one side and what may be part of a rectangle symbol on the other, which suggests that it may have come from a symbol-bearing cross-slab. Another Mail fragment displays part of an inscription that wraps around two sides of the slab (no.51) and was found close to the old kirkyard, while another came from grave-digging within the ruins of the church itself (no.53). The Mail stones vary in their script and represent the hand of more than one stonecarver.

The longest inscription is that on the Bressay cross-slab, which is clearly memorial in function, but one of the Mail, Cunningsburgh, fragments (no.51) is part of a longer inscription and it is thought perhaps to have been a territorial marker. The Lunnasting inscription includes the Pictish personal name of Nechton (no.52) and may also have been a boundary marker, given its location in a bog rather than a churchyard (the peat probably grew after the stone had been set up). It was first published in 1878 by the Shetland antiquarian Gilbert Goudie, who described it as 'a weird-like waif, most strikingly suggestive of a rude district and a remote age'. Two years earlier, at St Ninian's Isle, Goudie had been fortunate enough to discover, in the sand at the chapel site, ogham-inscribed slab no.48, together with another fragment now lost. The inscription has been read by Katherine Forsyth as a memorial including the words 'meqq' meaning 'son of' and 'nannammovvest' which is presumably a personal name. It is thought that most, if not all, of the Shetland ogham inscriptions may date from after AD 800 when there was already some Norse influence in the islands. The inscriptions from Bressay, Mail and Lunnasting (nos 54, 53, 52) display the use of double dots to separate the words, which is thought to have been a local invention, perhaps influenced by similar usage in Norse runic inscriptions.

Early Christian Cross-slab from Bressay

The slender cross-slab from Culbinsburgh (or Culbinsgarth/Cullingsburgh) in Bressay (no.54) is instantly recognisable as a design derived from the earlier cross-slab from Papil (no.29), with circular cross-heads, clerics and beast, but there are also significant differences. There is carving on both sides of the slab, which is fussier and less symmetrical than Papil, and an inscription in ogham letters runs along both narrow long sides (faces *b* & *d*), reading 'the cross of Necrudad, daughter of An (in memory of her husband) Benises son of Droan'. This is a long and unusually informative inscription, which shows clearly that the stone was created and erected by a woman, Necrudad, in memory of her husband Benises, and we may suppose that they belonged to a Christian Picto-Norse family living in Bressay in the tenth century. Scandinavian influence is demonstrated by the use of the Norse word for daughter, while those for cross and son are Gaelic, and there are hints of Scandinavian taste in the coarse interlace enclosing the cross-head on face *c*. The use of dots between the words also reflects Scandinavian influence. This interesting slab is thus tangible evidence of the cultural admixture of tenth-century Shetland. The placename Culbinsburgh derives from Old Norse for 'Kolbein's fort', which suggests that the nearby broch, though centuries old, was still impressive in Norse times.

Although on both sides of the slab the cross is contained within a circle and lacks a shaft, there is an illusion between the two clerics on face *a* of a hidden shaft, which bears a horse and rider. This horseman occupies a prime position and may depict the warlord, Benises, for whom the slab was erected. Both sides of the slab have a frame that terminates at the top in two opposing animal heads, which is a device familiar from mainland Pictland. All four clerics are wearing hooded robes

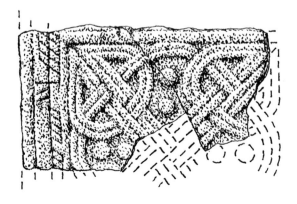

These beautifully carved fragments of a cross-slab from Kirkhouse, South Whiteness, display an ogham inscription along the intact edge, no.49. 1:5 SC1134145

with book satchels over their shoulders, and each carries a staff. They are well carved but the animals are somewhat clumsy. The pair of animals beneath the cross-head on face *c* may be lions, and the little animal at the foot of face *a* may be a pig or perhaps a bear.

Face *a* is assumed to be the front side of the slab, owing to its similarities with the Papil cross-slab, but the fact that the carving on face *c* stops short of that on the other side may indicate that face *c* was set up against the east end of the grave mound. We know nothing of the original location of the slab in the graveyard, however, for it was found, clearly displaced, on 'a waste piece of ground at Culbinsgarth near the old ruined church of St Mary, at Culbinsburgh' (Allen & Anderson 1903,6).

Early Christian Cross-marked Slabs

Simple cross-slabs were probably personal grave-markers and vary from linear incised crosses such as no.70, outline incised crosses, such as no.56, to pocked sunken crosses, such as no.61, some of which have expanded terminals, such as no.62 all of which can be matched in western Scotland. Many come from St Ninian's Isle and demonstrate the long usage of the kirkyard there for burial. The fine expansional crosses from Papil (no.59) and Kirkhouse, South Whiteness (no.60) show yet another stylistic link with Iona, in this instance in Norse times, and the chronology is underlined by the discovery in the same churchyard in South Whiteness of a Viking-age axe in a slab-lined grave (with a single artefact, this need not have been a pagan grave). The church was dedicated to St Olaf, the Norse saint, and the placename Hoove some 2 kilometres to the north comes from Old Norse *hof* and suggests the former presence on the Ness of an important Norse estate. The narrow South Whiteness slab bears assured interlace carving on the reverse (no.60). Again from South Whiteness, the fragment no.58 with its key pattern decoration could be part of a recumbent monument, rather than an upright cross-slab.

The incised linear cross on no.66 stands out as unique in form among the Shetland cross-slabs, and this was the slab that was re-used to cover the silver treasure at St Ninian's Isle. The double crosses on nos 68 and 69 and possibly no.67 are also very unusual among the Shetland assemblage.

Detail of the unusual incised cross on slab no.70 from St Ninian's Isle. 1:2.5 SC1158209

Runic Inscriptions

The Scandinavian runic alphabet was introduced into Shetland by Norse colonists, who used it mostly for memorial inscriptions from the tenth century, the latest of which is a recumbent graveslab of around AD 1300 in Crosskirk graveyard at Esha Ness in west Shetland (not included in this volume but written up by Barnes & Page (2006, 134–7). There are six surviving runic inscriptions from Shetland, of which the most complete (no.76) reads 'In memory of his/her father, Thorbjorn', and most appear to have been personal memorials. Part of a scribbled graffito was found during excavations at Gungstie in Noss (no.78), and single letters appear on two stones from Bressay (nos 79 & 80) (there are also single runes among the assemblage of slate graffiti from Jarlshof).

Cruciform Stones

Common but not unique to the northern islands of Shetland are stone grave-markers roughly shaped into crosses in the round, all to be found

Carved Stones

Relief Crosses
There are just two surviving examples of upright relief crosses (nos 124 & 125), where the background stone has been removed to leave the cross in relief, and the work involved in creating this effect was considerable in the case of no.125 from Framgord. This stone was doubtless influential in leading to the recumbent monument with relief cross as no.128.

Hogback and Recumbent Monuments
The small hogback gravestone from St Ninian's Isle, Dunrossness (no.126), was found during excavations in 1957 and can now be seen in the Shetland Museum in Lerwick. It is undecorated but has the typical hogback shape and dates probably to the eleventh century. Perhaps a century later a longer and flatter version of a hogback was created for a grave at Baliasta in Unst (no.127), which was at the start of a local fashion for 'keeled' recumbent gravestones, such as those in the kirkyard at Framgord, Sandwick (RCAHMS 1946, 127, no.1539). The 'keel' is the flat raised rib along the top of the monument. At Framgord there is a recumbent gravestone (no.128) bearing a relief cross with expanded terminals that could also belong to the twelfth century.

Curiosities
Two fragments of stone from the beach below Jarlshof (no.129) together bear an incised design which most resembles a sea-horse such as that on a stone from Ness in Orkney (illustrated in Mack 2007, fig 113). The decoration on the lower part of the body is similar to the 'stopped plait' ornament on Viking-age stones in the Isle of Man, and the Jarlshof stone may be a rare example in the Northern Isles of carving inspired by Scandinavian art styles. This possibility is strengthened by O'Meadhra's recognition of a Scandinavian motif-piece in Ringerike style amongst the slate graffiti from Jarlshof (1993, 436). The original outline of the slab is difficult to determine, though parts of three sides survive with a distinct chamfer 28–32mm deep, and it seems likely that it decorated a building rather than marked a grave.

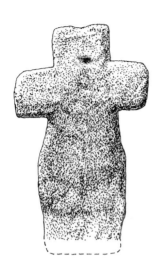

Simple grave-markers like this were commonly used in the northernmost islands of Shetland: this one is in the graveyard at Norwick in Unst, no.110. 1:10 SC1135113

in graveyards and indicative of the sites of Norse churches in Yell and Unst (nos 81–123). No fewer than 42 survive today and doubtless there are more below ground level in these and other churchyards (incised crosses are mentioned by RCAHMS (1946, 126) on crosses at Norwick, but none is visible today, and others are mentioned in their field notebooks). Similar cruciform stones occur elsewhere in Scotland, for instance at several sites in the inner and outer Hebrides (Fisher 2001, 17, figs 31–2) and at St Luke's Chapel, Kildrummy, Aberdeenshire (RCAHMS 2007, 129), and they may have been more widespread in mainland Scotland than their surviving distribution would suggest. There are also a few examples in Norway and Ireland (Fisher 2002, 56; 2005). These very simply sculpted crosses are the equivalent of small wooden crosses and mark the graves of unnamed ordinary people. Occasionally there is an incised cross as no.103 or a relief cross as no.117, but mostly they are quite plain though anthropomorphic in shape and oddly moving in effect.

Built into the medieval church at Lundawick in Unst is a slab incised with what is sometimes interpreted as a fish (no.130). It is on the underside of a lintel over a window and the right-hand end of the carving is hidden, but it resembles a club-like implement or even a bird rather than a fish and its date is uncertain, particularly as it had been re-used as the lintel. Similar doubts surround the so-called eagle on a boulder found near the broch at Islesburgh, where the outline of a crude and unidentifiable 'bird in flight' can be made out with the eye of faith (no.131).

There are tantalising records of a carved stone from South Garth in Yell, but it was lost in the nineteenth century and we have not included it here. It was described thus: 'Both sides were completely covered with figures in relief having a border all round carved in zig-zag diamond and spiral lines' (Allen & Anderson 1903, III, 15; Fisher 2002, 55). This sounds like an elaborately sculpted cross-slab, for the 'figures' probably refer to designs generally rather than solely human figures, and its loss is greatly regretted.

Conclusions

Discoveries in Shetland over the last three centuries have accumulated into an impressive assemblage of early medieval carved stones. Pictish symbol stones and symbol-bearing cross-slabs tended to be relatively tall and narrow, and the rectangle and double-disc and Z-rod are the most common symbols amongst the surviving stones and discs. There appears to have been a particular taste for cruciform designs within circles and for the S-scroll motif, and there are strong links in style between stone carving and the silverwork in the St Ninian's Isle treasure. The wolf-headed man from Mail is a rare reference to pagan religion and may be associated with the small decorated stone discs that are a class of artefact unique to Shetland. Papil in West Burra and St Ninian's Isle were important ecclesiastical centres and have between them yielded more parts of stone shrines than anywhere else in Scotland. The book satchels depicted on the shrine panel and cross-slab from Papil and on the Bressay cross-slab provide a graphic detail of church life that is unparalleled in Scottish stone carving. External links can be traced between the Shetland islands and mainland Pictland, the Christian west of Scotland and Viking-age Norway.

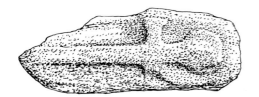

The graveyard at Framgord in Unst has an unusual number of recumbent graveslabs, including this one with a relief cross, no.128. 1:5 SC1160411

Drawings of Carved Stones

Notes on Drawings
'Drawing should be fundamental to our methods of archive: a necessary counter to the inevitable omissions of two-dimensional photography, limited as it is to a chosen pattern of lighting' (Scott 1997, 131). With this in mind, every carved surface of every stone has been drawn and is presented here at uniform scales in order that like may be compared with like: thus monumental carved stones are presented at scales of 1:10 and 1:5, small portable artefacts at a scale of 1:2.5, and the simple cruciform stones and recumbent monuments at 1:20. Legibility has required that runic inscriptions are presented at a scale of either 1:5 or 1:10. The slightly different style of drawing of nos 1 and 65, for example, indicates that these are lost stones drawn from old records, and dashed lines have been used to indicate the likely continuation of a design or, in the case of no.127, the hidden but measurable length of the stone.

Some of the carved stones of Shetland have been published previously, with the result that they have been numbered more than once and often in addition to their museum accession numbers. To avoid confusion, we have adopted an internally consistent system of numbering and have provided a Summary Catalogue and Concordance, which clarifies the identification of each stone.

Pictish and Viking-Age Carvings from Shetland

1

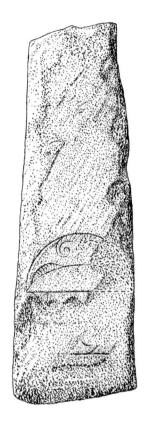

2

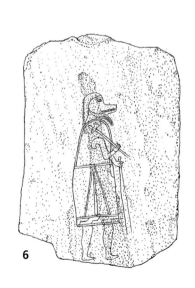

6

Pictish Symbol Stones

1 Sandness, Walls (lost) 1:10 SC1133739

2 Breck of Hillwell, Dunrossness 1:10 SC952436

3 'Lerwick Museum' 1:5 SC1134024

4 Uyea, Unst 1:5 SC1134024

5 Mail, Cunningsburgh 1:5 SC1105719

6 Mail, Cunningsburgh (see p3) 1:20 SC961063

Pictish Symbol Stones

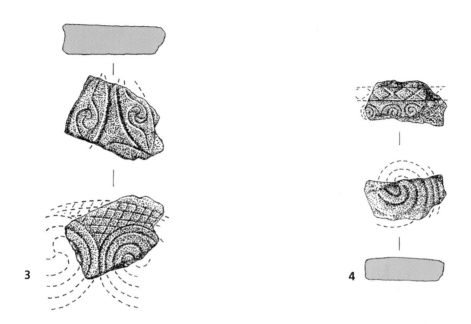

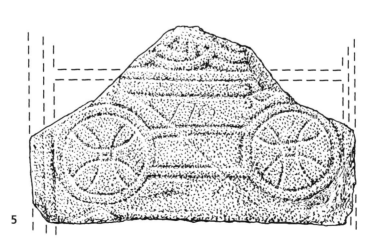

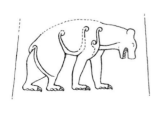

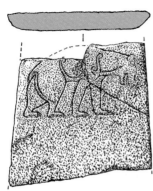

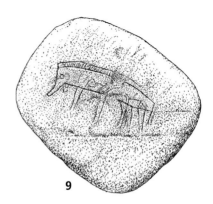

7 Old Scatness, Sumburgh (see p2) 1:10 SC1132401

8 Old Scatness, Sumburgh 1:5 SC1134030

9 Old Scatness, Sumburgh (see p2) 1:5 SC961062

10 Clickhimin, Lerwick 1:10 SC1134031

Pictish Stone Discs and other Small Artefacts

11 Old Scatness, Sumburgh 1:2.5 SC1134038

12 Kebister, Lerwick 1:2.5 SC1134039

13 Northmavine 1:2.5 SC1134040

14 Mail, Cunningsburgh 1:2.5 SC1134040

15 Scalloway (see p iv) 1:2.5 SC1134040

Pictish Symbol Stones, Discs and other Small Artefacts

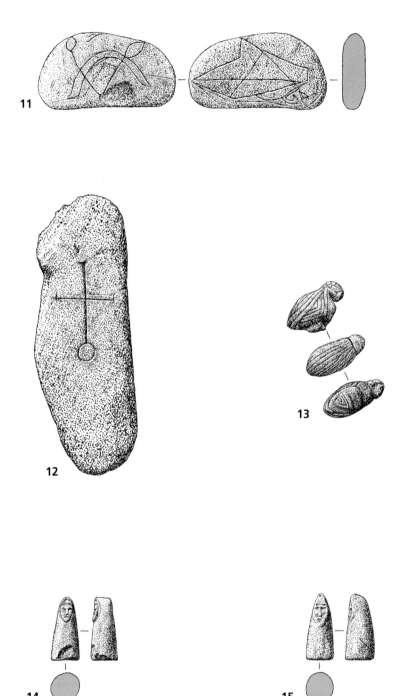

11

12

13

14 15

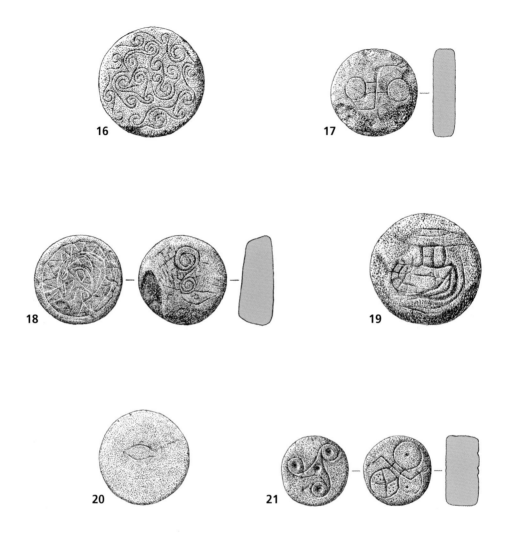

16 Jarlshof, Sumburgh 1:2.5 SC1132447
17 Jarlshof, Sumburgh 1:2.5 SC1134047
18 Jarlshof, Sumburgh 1:2.5 SC1134053
19 Jarlshof, Sumburgh 1:2.5 SC1132447
20 Burn of Noss, Dunrossness 1:2.5 SC1132447
21 Eswick, Nesting 1:2.5 SC1134041
22 Gletness, Nesting 1:2.5 SC1134041

Pictish Stone Discs and other Small Artefacts

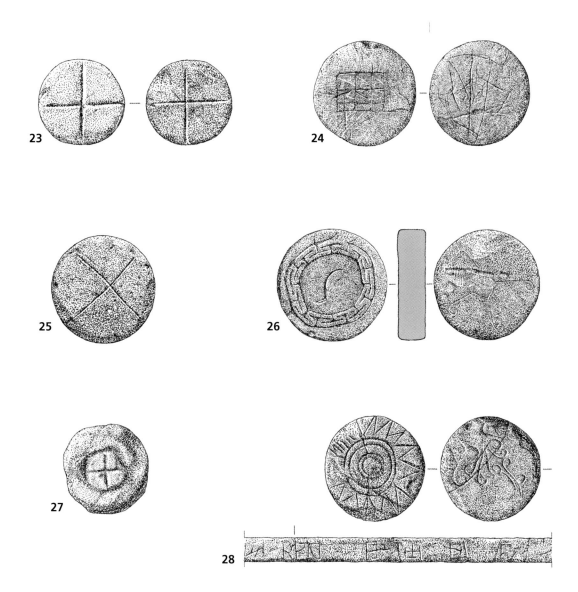

23 Jarlshof, Sumburgh 1:2.5 SC1132447

24 Ness of Burgi, Dunrossness 1:2.5 SC1134041

25 Jarlshof, Sumburgh 1:2.5 SC1134047

26 Ness of Burgi, Dunrossness 1:2.5 SC1134047

27 Jarlshof, Sumburgh 1:2.5 SC1132447

28 'Lerwick Museum' 1:2.5 SC1134047

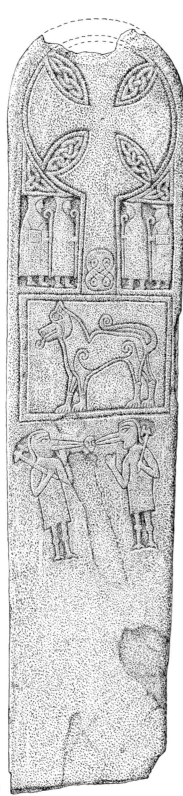

Early Christian Cross-slab from Papil

29 Papil, West Burra (see p4) 1:10 SC1133106

Early Christian Stone Shrines

30 Monks Stone, Papil, West Burra 1:10 SC1009955

31 St Ninian's Isle 1:10 SC1134056, SC1134059

Key to Shrine Post Sections

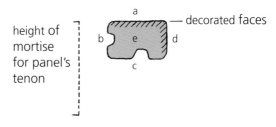

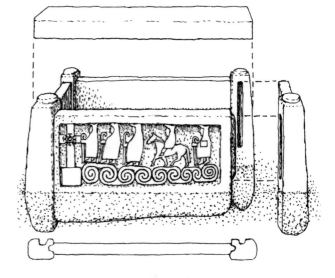

Conjectural reconstruction of a composite stone shrine, showing how the side panels slotted into the corner posts and how the whole shrine would have been sunk into the ground for stability. 1:10 SC1134054

Early Christian Cross-slab & Stone Shrines

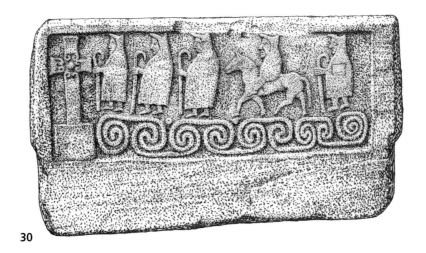

30

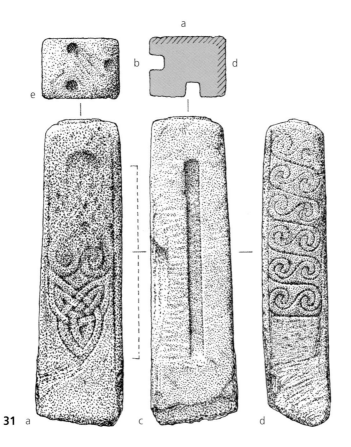

31 a c d

Pictish and Viking-Age Carvings from Shetland

32 St Ninian's Isle 1:10 SC1134056, SC1134059
33 St Ninian's Isle 1:10 SC1134058, SC1134060
34 St Ninian's Isle (see p6) 1:10 SC1134057, SC1134059
35 St Ninian's Isle 1:10 SC1134061

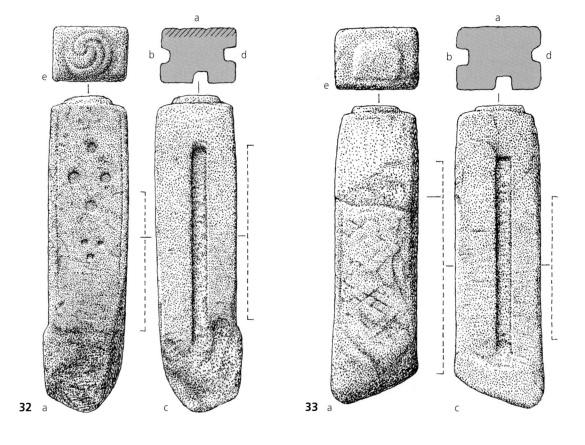

Early Christian Shrines

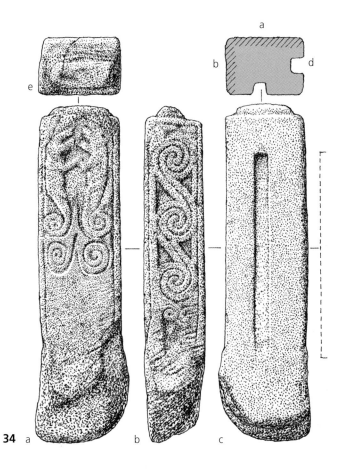

34

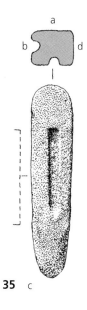

35

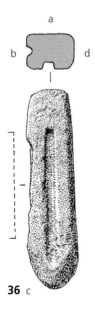
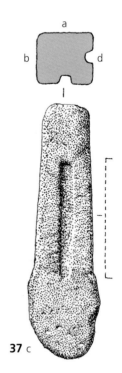

36 Papil, West Burra 1:10 SC1134067

37 St Ninian's Isle 1:10 SC1134068

38 Papil, West Burra 1:10 SC1134058, SC1134061

39 Papil, West Burra 1:10 SC1134067

40 St Ninian's Isle (possible panel) 1:10 SC1134143

41 Papil, West Burra 1:10 SC1134067

Early Christian Shrines

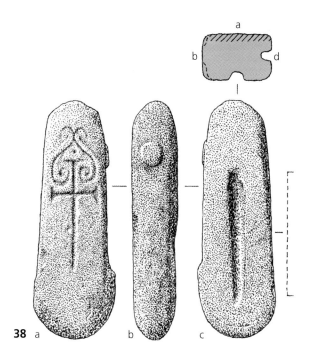

38 a b c

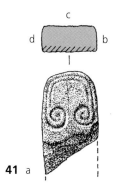

41 a

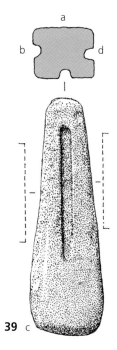

39 c

40

23

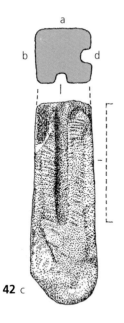

42 c

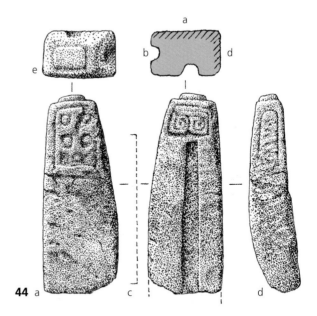

44 a c d

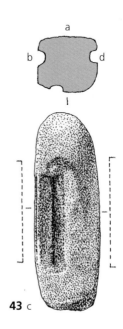

43 c

42 Papil, West Burra 1:10 SC1134068

43 Papil, West Burra 1:10 SC1134067

44 St Ninian's Isle 1:10 SC1134057

45 St Ninian's Isle 1:10 SC1134060

46 Gungstie, Noss 1:10 SC1134068

47 St Ninian's Isle 1:10 SC1134061

Early Christian Shrines

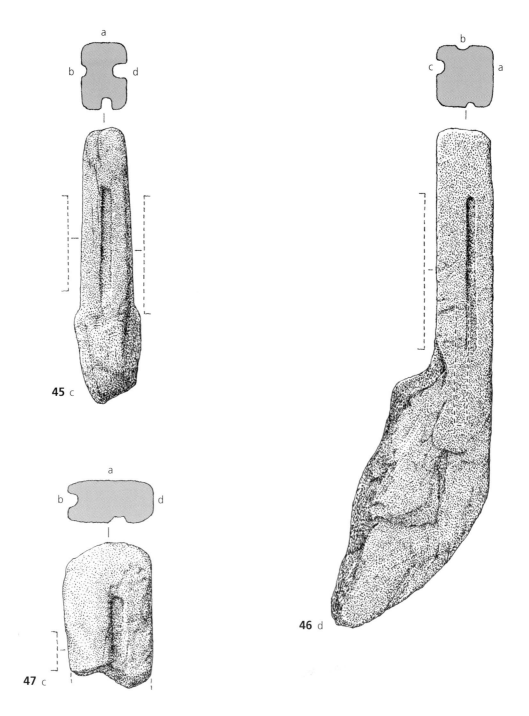

45 c

47 c

46 d

Pictish and Viking-Age Carvings from Shetland

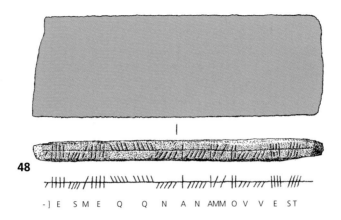

48

-] E SM E Q Q N A N AMM O V V E ST

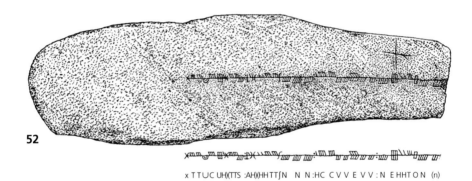

52

x T TUC UH)(TTS :AH)(HHTTʃN N N :HC C V V E V V : N E HHT O N (n)

Key to ogham readings

Small caps are used for reasonably secure readings. Brackets enclose readings about which there is doubt, either because the lettering is damaged or incomplete, or because a legible symbol is of uncertain orthographic value. The orthographic value of the following symbols is not known: ×,)(, ʃ, dd . Square brackets are used to indicate an incomplete text due to breakage. The symbol ' : ' represents a similar symbol on the stone. The direction of reading of individual segments of the various Cunningsburgh inscriptions is uncertain (this affects the identification of some individual letters). The most likely direction is given here. The direction of reading of the others is certain (nos 54 Bresssay, 48 St Ninian's Isle, 52 Lunnasting) or likely (no.49 South Whiteness).

Ogham Inscriptions

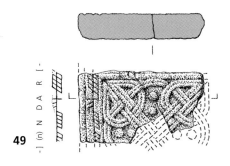

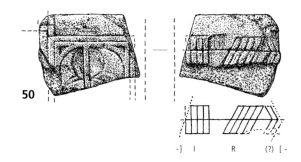

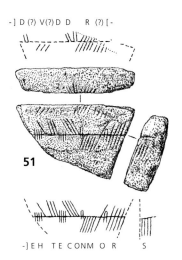

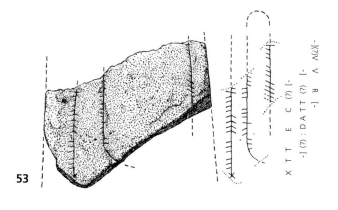

Ogham Inscriptions

48 St Ninian's Isle 1:10 SC1134144

49 Kirkhouse, South Whiteness (see p7) 1:10 SC1134145

50 Mail, Cunningsburgh 1:10 SC1134146

51 Mail, Cunningsburgh 1:10 SC1134191

52 Lunnasting 1:10 SC1134197

53 Mail, Cunningsburgh 1:10 SC1134198

Pictish and Viking-Age Carvings from Shetland

Early Christian Cross-slab from Bressay

54 Culbinsburgh, Bressay 1:10 SC1132448, SC1132449

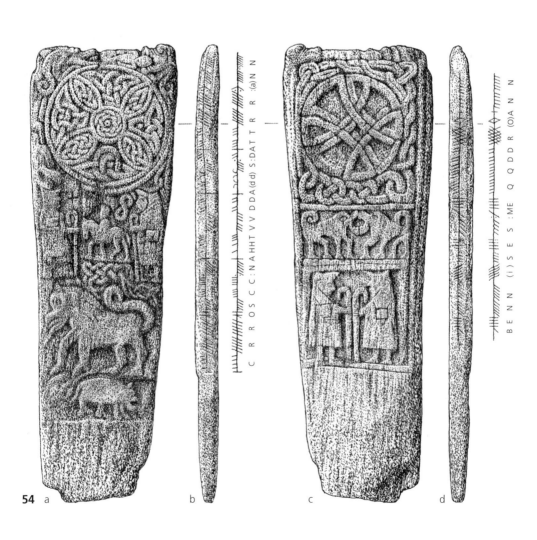

54 a b c d

Early Christian Cross-marked Slabs

55 St Ninian's Isle 1:10 SC1134199

56 St Ninian's Isle 1:10 SC1134200

57 Papil, West Burra 1:10 SC1134207

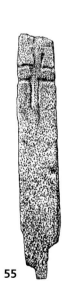

55

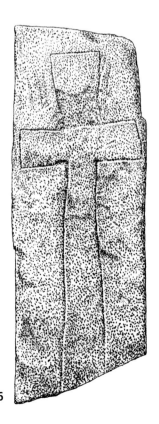

56

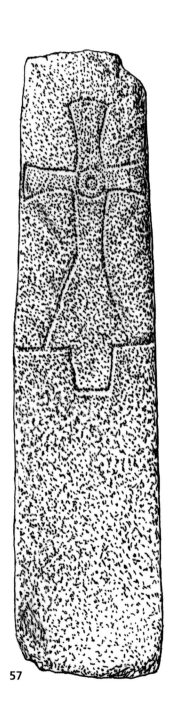

57

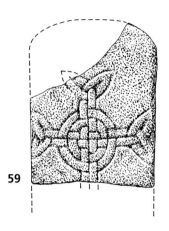
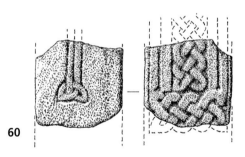

58 Kirkhouse, South Whiteness 1:10 SC1134208

59 Papil, West Burra 1:10 SC1158200

60 Kirkhouse, South Whiteness 1:10 SC1135579

61 St Ninian's Isle 1:10 SC1134210

Early Christian Cross-marked Slabs

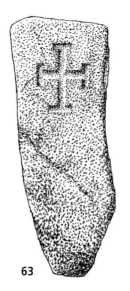

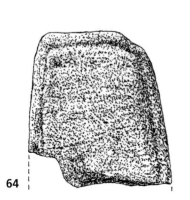

62 St Ninian's Isle 1:10 SC1134210

63 Gungstie, Noss 1:10 SC1135112

64 St Ninian's Isle 1:10 SC1134211

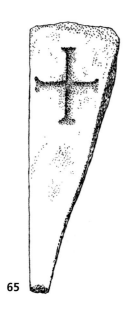
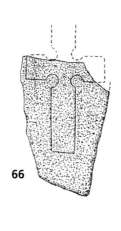
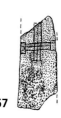
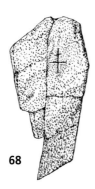
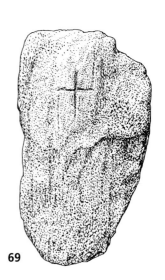

65 Kirk of Gloup, Yell (lost) 1:10 SC1134212

66 St Ninian's Isle 1:10 SC1134213

67 Gungstie, Noss 1:10 SC1134213

68 St Ninian's Isle 1:10 SC1134199

69 St Ninian's Isle 1:10 SC1158217

Early Christian Cross-marked Slabs

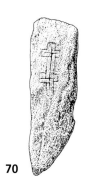

70

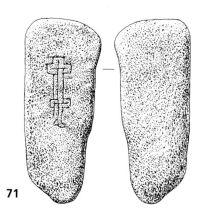

71

72

70 St Ninian's Isle (see p8) 1:5 SC1158209

71 St Ninian's Isle 1:5 SC1158205

72 St Ninian's Isle 1:5 SC1158210

Pictish and Viking-Age Carvings from Shetland

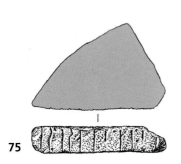
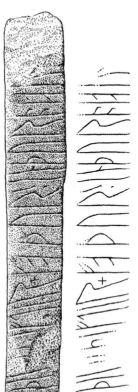

Runic Inscriptions

73 Aith Voe, Cunningsburgh 1:5 SC1134214

74 Aith Voe, Cunningsburgh 1:5 SC1134214

75 Papil, West Burra 1:5 SC1134215

76 Mail, Cunningsburgh 1:10 SC1134216

Runic Inscriptions

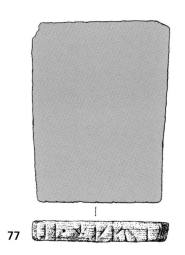

77 Cross Kirk, Esha Ness 1:5 SC1134227

78 Gungstie, Noss 1:5 SC1134426

79 Bressay 1:10 SC1134436

80 Bressay 1:10 SC1134436

81

82

83

84

85

86

Cruciform Stones

81 St Ninian's Isle 1:20 SC1135112

82 Houll, North Roe 1:20 SC1161284

83 Houll, North Roe 1:20 SC1161284

84 Coppister, Yell 1:20 SC1160486

85 North Kirk Geo, Yell 1:20 SC1160497

86 North Kirk Geo, Yell 1:20 SC1160498

87 North Kirk Geo, Yell 1:20 SC1160499

87

Cruciform Stones

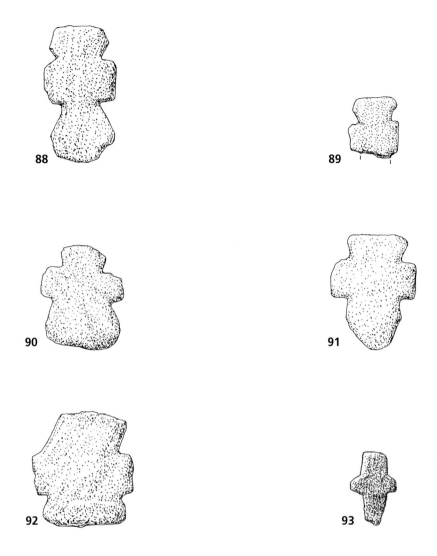

88 North Kirk Geo, Yell 1:20 SC1160500
89 North Kirk Geo, Yell 1:20 SC1160504
90 North Kirk Geo, Yell 1:20 SC1160501
91 North Kirk Geo, Yell 1:20 SC1160502
92 North Kirk Geo, Yell 1:20 SC1160503
93 Ulsta, Yell 1:20 SC1135112

Pictish and Viking-Age Carvings from Shetland

94

95

96

97

98

99

100

94 West Sandwick, Yell 1:20 SC1161254
95 West Sandwick, Yell 1:20 SC1161255
96 West Sandwick, Yell 1:20 SC1161256
97 West Sandwick, Yell 1:20 SC1161257
98 Reafirth, Yell 1:20 SC1161272
99 Reafirth, Yell (lost) 1:20 SC1161273
100 Reafirth, Yell (lost) 1:20 SC1161274

Cruciform Stones

101

102

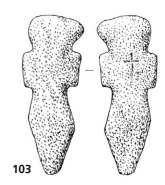
103

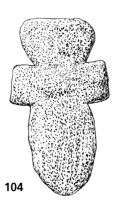
104

105

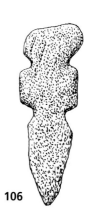
106

101 Reafirth, Yell (lost) 1:20 SC1161275
102 Lundawick, Unst 1:20 SC1161162
103 Lundawick, Unst 1:20 SC1161155
104 Lundawick, Unst 1:20 SC1161156
105 Lundawick, Unst 1:20 SC1161157
106 Lundawick, Unst 1:20 SC1161158

 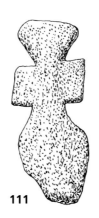 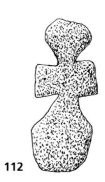

107 Lundawick, Unst (lost) 1:20 SC1161159

108 Lundawick, Unst (lost) 1:20 SC1161160

109 Lundawick, Unst (lost) 1:20 SC1161161

110 Norwick, Unst (see p9) 1:20 SC1135113

111 Norwick, Unst 1:20 SC1160404

112 Norwick, Unst 1:20 SC1160405

Cruciform Stones

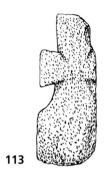 113
 114
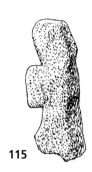 115

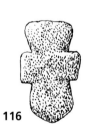 116
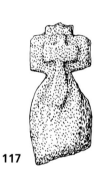 117

113 Norwick, Unst 1:20 SC1160406
114 Framgord, Unst 1:20 SC1160407
115 Framgord, Unst 1:20 SC1160408
116 Framgord, Unst 1:20 SC1160409
117 Framgord, Unst 1:20 SC1160410

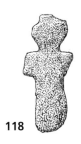

118

119

120

121

118 Framgord, Unst 1:20 SC1135114
119 Framgord, Unst 1:20 SC1135114
120 Tresta, Fetlar 1:20 SC1135114
121 Tresta, Fetlar 1:20 SC1135114

Cruciform Stones & Relief Crosses

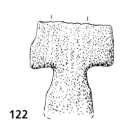

122

123

124

125

122 Uyea, Unst 1:20 SC1161142

123 Uyea, Unst 1:20 SC1161143

Relief Crosses

124 Lundawick, Unst 1:20 SC1135114

125 Framgord, Unst (lost) 1:20 SC1135115

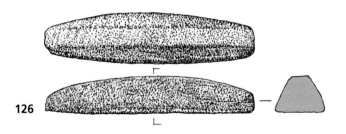

126

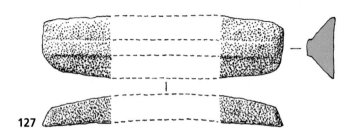

127

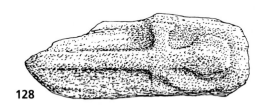

128

Hogback and Recumbent Monuments

126 St Ninian's Isle 1:20 SC1135142

127 Baliasta, Unst 1:20 SC1135112

128 Framgord, Unst (see p10) 1:20 SC1160411

Hogback and Recumbent Monuments & Curiosities

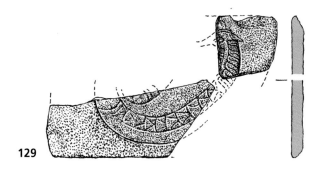

129

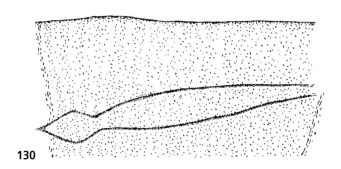

130

131

Curiosities

129 Jarlshof, Sumburgh 1:10 SC1135143

130 Lundawick, Unst 1:10 SC1135144

131 Islesburgh 1:10 SC1135145

Pictish and Viking-Age Carvings from Shetland

Summary Catalogue and Concordance

Site Name	Catalogue Number	Museum Accession	Thomas 1973	Allen 1903	Fraser 2008	Barnes & Page 2006	Additional Main References
Pictish Symbol Stones							
Sandness, Walls HU15NE 8 HU 19125765	1	lost		p4	199		Low 1879, 121
Breck of Hillwell, Dunrossness HU31SE 39 HU 372146	2	SM A59.1997			194		DES 1997, 67
Original location uncertain, possibly Papil, Yell	3	NMS IB.19		p1	196		'Lerwick Museum', SHC vol 2, 85–6
Uyea, Unst HU69NW 6 HU 608 985	4	NMS IB.18		p5	200		
Mail, Cunningsburgh HU42NW 5.1 HU 4330 2790	5	SM A42.2008					Ritchie 2008
Mail, Cunningsburgh HU42NW 5.1 HU 4330 2790	6	SM ARC 1992.1000			197		Turner 1994; Ritchie et al 2006, 16–19
Old Scatness, Sumburgh HU31SE 21 HU 3898 1065	7	SF34210			198.1		Dockrill et al 2010
Old Scatness, Sumburgh HU31SE 21 HU 3898 1065	8	SF43719			198.4		Dockrill et al 2010
Old Scatness, Sumburgh HU31SE 21 HU 3898 1065	9	SF8492			198.2		Dockrill et al 2010
Footprints							
Clickhimin, Lerwick HU44SE 2.0 HU 4643 4081	10	on site (Historic Scotland)					Hamilton 1968, 151–6
Small Artefacts							
Old Scatness, Sumburgh HU31SE 21 HU 3898 1065	11	SF9101					Dockrill et al 2010

Pictish and Viking-Age Carvings from Shetland

Site Name	Catalogue Number	Museum Accession	Thomas 1973	Allen 1903	Fraser 2008	Barnes & Page 2006	Additional Main References
Kebister, Lerwick HU44NE 5.2 HU 4570 4550	12	SF425					Owen & Lowe 1999, 220–3
Northmavine, exact location unknown	13	NMS BG.392					
Mail, Cunningsburgh HU42NW 5.1 HU 4330 2790	14	NMS NS.36					*PSAS* 48 (1924–6), 17; Ritchie *et al* 2006, 61–3
Scalloway HU43NW 32 HU 406 399	15	SM ARC4840					Sharples 1998, 174–5; Ritchie *et al* 2006, 61–3
Jarlshof, Sumburgh HU30NE 1.1 HU 3981 0955	16	SM ARC66138					Bruce 1906–7, 33, fig 16; Hamilton 1956, 85, pl XVII
Jarlshof, Sumburgh HU30NE 1.1 HU 3981 0955	17	NMS HSA.4042		213			Curle 1933–4, 229, fig 5; Hamilton 1956, 84, pl XVII
Jarlshof, Sumburgh HU30NE 1.1 HU 3981 0955	18	NMS HSA.4041					Hamilton 1956, 84, pl XVII
Jarlshof, Sumburgh HU30NE 1.1 HU 3981 0955	19	SM ARC66139					Johnstone 1980, 153, fig 11.18
Burn of Noss, Scousburgh, Dunrossness HU31NE 15 HU 3615 1680	20	SM ARC65218					
Eswick, Nesting HU45SE 74 HU 4882 5380	21	SM ARC2003.290		212			*DES* 2004, 181
Gletness, Nesting HU 46 51	22	NMS BG.392					
Jarlshof, Sumburgh HU30NE 1.1 HU 3981 0955	23	SM ARC66140					
Ness of Burgi, Dunrossness HU30NE 2 HU 3878 0839	24	NMS GA.138					*PSAS* 17 (1882–3), 296–7
Jarlshof, Sumburgh HU30NE 1.1 HU 3981 0955	25	NMS GA.422					
Ness of Burgi, Dunrossness HU30NE 2 HU 38780839	26	NMS GA.137		214			*PSAS* 17 (1882–3), 296–7
Jarlshof, Sumburgh HU30NE 1.1 HU 3981 0955	27	SM ARC66139A					
Original location uncertain	28	NMS BG.151					'Lerwick Museum'
Pictish Cross-slab							
Papil, West Burra HU33SE 2 HU 3698 3141	29	NMS IB.46	pp 10–15				Moar & Stewart 1943–4; Stevenson 1981, 284–5
Early Christian Stone Shrines – Panels							
Monks Stone, Papil, West Burra HU33SE 2 HU 3698 3141	30	SM ARC6634	23				Moar & Stewart 1943–4; Stevenson 1981, 288–9

Summary Catalogue and Concordance

Site Name	Catalogue Number	Museum Accession	Thomas 1973	Allen 1903	Fraser 2008	Barnes & Page 2006	Additional Main References
St Ninian's Isle, Dunrossness HU32SE 4 HU 3685 2090	40	SM ARC7433	36				

Early Christian Stone Shrines – Posts

Site Name	Catalogue Number	Museum Accession	Thomas 1973	Allen 1903	Fraser 2008	Barnes & Page 2006	Additional Main References
St Ninian's Isle, Dunrossness HU32SE 4 HU 36852090	31	SM ARC6685	1				
St Ninian's Isle, Dunrossness HU32SE 4 HU 36852090	32	SM ARC6686	2				
St Ninian's Isle, Dunrossness HU32SE 4 HU 36852090	33	SM ARC67121	4				
St Ninian's Isle, Dunrossness HU32SE 4 HU 36852090	34	SM ARC6684	3				
St Ninian's Isle, Dunrossness HU32SE 4 HU 36852090	35	SM ARC1996.218					
Papil, West Burra HU33SE 2 HU 36983141	36	SM ARC7432	35				
St Ninian's Isle, Dunrossness HU32SE 4 HU 36852090	37	SM ARC8884					
Papil, West Burra HU33SE 2 HU 36983141	38	SM ARC6635A	27				Moar & Stewart 1943–4
Papil, West Burra HU33SE 2 HU 36983141	39	SM ARC6635B	26				
Papil, West Burra HU33SE 2 HU 36983141	41	SM ARC6639	30				
Papil, West Burra HU33SE 2 HU 36983141	42	SM ARC67127	24				
Papil, West Burra HU33SE 2 HU 36983141	43	SM ARC67126	25				
St Ninian's Isle, Dunrossness HU32SE 4 HU 36852090	44	SM ARC 67120	5				
St Ninian's Isle, Dunrossness HU32SE 4 HU 36852090	45	SM ARC 67125	8				
Gungstie, Noss HU54SW 9 HU 53074094	46	SM ARC1994.726					*DES* 1994, 93
St Ninian's Isle, Dunrossness HU32SE 4 HU 36852090	47	SM ARC 67124	9				

Ogham Inscriptions

Site Name	Catalogue Number	Museum Accession	Thomas 1973	Allen 1903	Fraser 2008	Barnes & Page 2006	Additional Main References
St Ninian's Isle, Dunrossness HU32SE 4 HU 36852090	48	NMS IB.112			p11		Forsyth 1996, 467–79 (St Ninian's Isle 1)

Pictish and Viking-Age Carvings from Shetland

Site Name	Catalogue Number	Museum Accession	Thomas 1973	Allen 1903	Fraser 2008	Barnes & Page 2006	Additional Main References
Kirkhouse, South Whiteness HU34SE 3 HU 38664442	49	NMS IB.256 & SM ARC8057					Stevenson 1981, 285–7; Forsyth 1996, 495–502
Mail, Cunningsburgh HU42NW 5.1 HU 4330 2790	50	NMS IB.114	pp16–17	195			Forsyth 1996, 206–24 (Cunningsburgh 1)
Mail, Cunningsburgh HU42NW 5.1 HU 4330 2790	51	NMS IB.115	p16				Forsyth 1996, 206–24 (Cunningsburgh 2)
Lunnasting HU46NE 11 HU 46 65	52	NMS IB.113	pp17–18				Forsyth 1996, 402–19
Mail, Cunningsburgh HU42NW 5.1 HU 4330 2790	53	NMS IB.182					Forsyth 1996, 206–24 (Cunningsburgh 3)

Early Christian Cross-slab from Bressay

Site Name	Catalogue Number	Museum Accession	Thomas 1973	Allen 1903	Fraser 2008	Barnes & Page 2006	Additional Main References
Culbinsburgh, Bressay HU54SW 12 HU 521 423	54	NMS IB.109	pp5–10				Forsyth 1996, 117–38; Stevenson 1981, 284–5

Early Christian Cross-marked Slabs – Outline

Site Name	Catalogue Number	Museum Accession	Thomas 1973	Allen 1903	Fraser 2008	Barnes & Page 2006	Additional Main References
St Ninian's Isle, Dunrossness HU32SE 4 HU 3685 2090	55	SM ARC6643	11				
St Ninian's Isle, Dunrossness HU32SE 4 HU 3685 2090	56	at Bigton Church	18				
Papil, West Burra HU33SE 2 HU 3698 3141	57	SM ARC67128	34				
Kirkhouse, South Whiteness HU34SE 3 HU 3866 4442	58	NMS IB.257					Stevenson 1981, 287
Papil, West Burra HU33SE 2 HU 3698 3141	59	SM ARC6636	32				Moar & Stewart 1943–4; Stevenson 1981, 285
Kirkhouse, South Whiteness HU34SE 3 HU 3866 4442	60	NMS IB.248					

Early Christian Cross-marked Slabs – Sunken

Site Name	Catalogue Number	Museum Accession	Thomas 1973	Allen 1903	Fraser 2008	Barnes & Page 2006	Additional Main References
St Ninian's Isle, Dunrossness HU32SE 4 HU 3685 2090	61	SM ARC6641	13				
St Ninian's Isle, Dunrossness HU32SE 4 HU 3685 2090	62	SM ARC67129	14				
Gungstie, Noss, Dunrossness	63	SM ARC1996.205					Fisher 2002, 54–5
St Ninian's Isle, Dunrossness HU32SE 4 HU 3685 2090	64	SM ARC67130	12				
Kirk of Gloup, Kirks, Yell HP50SW3 HP 5056 0485	65	lost					Irvine c1873; *SHC* vol 2, 187

Summary Catalogue and Concordance

Site Name	Catalogue Number	Museum Accession	Thomas 1973	Allen 1903	Fraser 2008	Barnes & Page 2006	Additional Main References
Early Christian Cross-marked Slabs – Incised							
St Ninian's Isle, Dunrossness HU32SE 4 HU 3685 2090	66	SM ARC6640	15				
Gungstie, Noss HU54SW 9 HU 5307 4094	67	SM ARC66116					
St Ninian's Isle, Dunrossness HU32SE 4 HU 3685 2090	68	SM ARC1993.120	10				
St Ninian's Isle, Dunrossness HU32SE 4 HU 3685 2090	69	SF494					Barrowman 2003, 56–7
St Ninian's Isle, Dunrossness HU32SE 4 HU 3685 2090	70	SF465					Barrowman 2003, 56–7
St Ninian's Isle, Dunrossness HU32SE 4 HU 3685 2090	71	SM SNI 2000– ED465					Barrowman 2003, 56–7
St Ninian's Isle, Dunrossness HU32SE 4 HU 3685 2090	72	SF 433					Barrowman 2003, 56–7
Runic Inscriptions							
Aith Voe, Cunningsburgh HU 437 287	73	NMS IB.104		p19		1	
Aith Voe, Cunningsburgh HU 437 287	74	NMS IB.105		p19		2	
Papil, West Burra HU33SE 2 HU 3698 3141	75	SM ARC65860	31			4	
Mail, Cunningsburgh HU42NW 5.1 HU 4330 2790	76	NMS IB.103				3	
Cross Kirk, Esha Ness HU27NW 6 HU 2123 7803	77	SM ARC65467				5	
Gungstie, Noss HU54SW 9 HU 5307 4094	78	SM ARC1995.88				7	
Bressay	79	NMS IB.107					
Bressay	80	NMS IB.106					
Cruciform Stones							
St Ninian's Isle, Dunrossness HU32SE 4 HU 3685 2090	81	ARC 6642	16				
Houll, North Roe HU38NE 32 HU 3666 8958	82	on site					
Houll, North Roe HU38NE 32 HU 3666 8958	83	on site					

Pictish and Viking-Age Carvings from Shetland

Site Name	Catalogue Number	Museum Accession	Thomas 1973	Allen 1903	Fraser 2008	Barnes & Page 2006	Additional Main References
Coppister, Yell HU 48 79	84	at Old Haa, Burravoe, Yell					
North Kirk Geo, Kirkhouse, Yell HU 450 837	85	on site					
North Kirk Geo, Kirkhouse, Yell HU 450 837	86	on site					
North Kirk Geo, Kirkhouse, Yell HU 450 837	87	on site					Fisher 2005, 164–5
North Kirk Geo, Kirkhouse, Yell HU 450 837	88	on site					Fisher 2005, 164–5
North Kirk Geo, Kirkhouse, Yell HU 450 837	89	on site					
North Kirk Geo, Kirkhouse, Yell HU 450 837	90	on site					
North Kirk Geo, Kirkhouse, Yell HU 450 837	91	on site					
North Kirk Geo, Kirkhouse, Yell HU 450 837	92	on site					
Ulsta, Yell HU48SE 1 HU 4640 8033	93	ARC 1996, 248					
West Sandwick, Yell HU48NE 1 HU 4522 8883	94	on site					
West Sandwick, Yell HU48NE 1 HU 4522 8883	95	on site					
West Sandwick, Yell HU48NE 1 HU 4522 8883	96	on site					
West Sandwick, Yell HU48NE 1 HU 4522 8883	97	on site					
Reafirth, Yell HU59SW 1 HU 5145 9095	98	on site					
Reafirth, Yell HU59SW 1 HU 5145 9095	99	lost					
Reafirth, Yell HU59SW 1 HU 5145 9095	100	lost					
Reafirth, Yell HU59SW 1 HU 5145 9095	101	lost					
Lundawick, Unst HP50SE 6 HP 5669 0409	102	on site					
Lundawick, Unst HP50SE 6 HP 5669 0409	103	on site					Fisher 2005, 165
Lundawick, Unst HP50SE 6 HP 5669 0409	104	on site					

Summary Catalogue and Concordance

Site Name	Catalogue Number	Museum Accession	Thomas 1973	Allen 1903	Fraser 2008	Barnes & Page 2006	Additional Main References
Lundawick, Unst HP50SE 6 HP 5669 0409	105	on site					
Lundawick, Unst HP50SE 6 HP 5669 0409	106	on site					
Lundawick, Unst HP50SE 6 HP 5669 0409	107	lost					RCAHMS 1946, iii, fig 665
Lundawick, Unst HP50SE 6 HP 5669 0409	108	lost					RCAHMS 1946, iii, fig 665
Lundawick, Unst HP50SE 6 HP 5669 0409	109	lost					RCAHMS 1946, iii, fig 665
Norwick, Unst HP61SE 1 HP 6517 1410	110	SM BEL1993.449					
Norwick, Unst HP61SE 1 HP 6517 1410	111	on site					Fisher 2005, 165
Norwick, Unst HP61SE 1 HP 6517 1410	112	on site					Fisher 2005, 165
Norwick, Unst HP61SE 1 HP 6517 1410	113	on site					
Framgord, Sandwick, Unst HP60SW 3 HP 6191 0291	114	on site					
Framgord, Sandwick, Unst HP60SW 3 HP 6191 0291	115	on site					
Framgord, Sandwick, Unst HP60SW 3 HP 6191 0291	116	on site					
Framgord, Sandwick, Unst HP60SW 3 HP 6191 0291	117	on site					
Framgord, Sandwick, Unst HP60SW 3 HP 6191 0291	118	on site					
Framgord, Sandwick, Unst HP60SW 3 HP 6191 0291	119	on site					
Tresta, Fetlar HU35SE 11 HU 3689 5098	120	on site					
Tresta, Fetlar HU35SE 11 HU 3689 5098	121	on site					
Uyea, Unst HU69NW 5 HU 6082 9852	122	on site					Fisher 2005, 165
Uyea, Unst HU69NW 5 HU 6082 9852	123	on site					

Pictish and Viking-Age Carvings from Shetland

Site Name	Catalogue Number	Museum Accession	Thomas 1973	Allen 1903	Fraser 2008	Barnes & Page 2006	Additional Main References
Relief Crosses							
Lundawick, Unst HP50SE 6 HP 5669 0409	124	Unst Heritage Centre					
Framgord, Sandwick, Unst HP60SW 3 HP 6191 0291	125	lost					Irvine c1873
Hogback and Recumbent Monuments							
St Ninian's Isle, Dunrossness HU32SE 4 HU 3685 2090	126	SM ARC 67123	17				Lang 1972–4, 231
Baliasta, Unst HP60NW 10 HP 6025 0958	127	in churchyard wall					
Framgord, Sandwick, Unst HP60SW 3 HP 6191 0291	128	on site					RCAHMS 1946, iii, fig 649
Curiosities							
Jarlshof serpent, Sumburgh HU30NE 1.1 HU 3981 0955	129	NMS HSA.782a & b					RCAHMS 1946, i, fig 5; Hamilton 1956, 189, pl XXXVII
Lundawick 'fish', Unst HP50SE 6 HP 5669 0409	130	window lintel in church					Ritchie 1997, 39; first recorded by JT Irvine, SA D.16/389/67/3
Islesburgh 'eagle' HU36NW 10 HU 3365 6918	131	SM ARC1992.716					Scott 1957

DES *Discovery & Excavation in Scotland*, Council for Scottish Archaeology (Archaeology Scotland)

NMS National Museums of Scotland, Edinburgh

PSAS *Proceedings of the Society of Antiquaries of Scotland*

SA Shetland Archive, Lerwick

SM Shetland Museum, Lerwick

SF Small Finds (Old Scatness Excavation)

'Lerwick Museum' indicates that the object (unprovenanced) was in the Museum of the Shetland Literary and Scientific Society in Lerwick until the collection was bought by the Society of Antiquaries of Scotland in 1883.

Bibliography

Allen, J R & Anderson, J 1903
The Early Christian Monuments of Scotland. Edinburgh: Society of Antiquities of Scotland (reprinted 1993 by The Pinkfoot Press, Balgavies (now Brechin), Angus).

Barnes, M & Page, R 2006
The Scandinavian Runic Inscriptions of Britain. Uppsala: Uppsala University.

Barrowman, R 2003
A decent burial? Excavations on St Ninian's Isle in July 2000, in Downes, J & Ritchie, A (eds) *Sea Change: Orkney and Northern Europe in the Later Iron Age AD 300–800*, 51–61. Balgavies, Angus: The Pinkfoot Press.

Barrowman, R C (ed) forthcoming
The Chapel and Burial Ground on St Ninian's Isle, Shetland: Excavations Past and Present. London: Society for Medieval Archaeology Monograph.

Bruce, J 1907
Notice of the excavation of a broch at Jarlshof, Sumburgh, Shetland, *Proc Soc Antiq Scot* 51 (1906–7), 11–33.

Buteux, S 1997
Settlements at Skaill, Deerness, Orkney. Oxford: Brit Archaeol Report, Brit Ser 260.

Cant, R G 1975
The Medieval Churches & Chapels of Shetland. Lerwick: Shetland Archaeological and Historical Society.

Curle, A O 1934
An account of further excavation at Jarlshof, Sumburgh, Shetland, in 1932 and 1933, on behalf of H.M. Office of Works, *Proc Soc Antiq Scot* 58 (1933–4), 224–319.

Dockrill, S J, Bond, J M, Brown, L D, Turner, V E, Bashford, D, Cussans, J E & Nicholson, R A 2010
Excavations at Old Scatness, Shetland. Vol 1. The Pictish Village and Viking Settlement. Lerwick: Shetland Heritage Publications.

Fisher, I 2001
Early Medieval Sculpture in the West Highlands and Islands. Edinburgh: RCAHMS/Society of Antiquaries of Scotland.

Fisher, I 2002
Crosses in the Ocean: some papar sites and their sculpture, in Crawford, B E (ed) *The Papar in the North Atlantic: Environment and History*, 39–57. St Andrews: St John's House Papers no.10.

Fisher, I 2005
Cross-currents in North Atlantic sculpture, in Mortensen, A & Arge, S V *Viking and Norse in the North Atlantic*, 160–6. Torshavn.

Fisher, I forthcoming
The carved stones, in Barrowman forthcoming.

Forsyth, K 1996
The ogham inscriptions of Scotland: an edited corpus. Unpublished PhD thesis, Harvard University.

Forsyth, K forthcoming
'An ogham-inscribed slab from St Ninian's Isle, found in 1876', in Barrowman (ed) forthcoming.

Fraser, I (ed) 2008
The Pictish Symbol Stones of Scotland. Edinburgh: Royal Commission on the Ancient and Historical Monuments of Scotland.

Goudie, G 1878
On two monumental stones with ogham inscriptions recently discovered in Shetland, *Proc Soc Antiq Scot* 12 (1876–8), 20–32.

Hamilton, J R C 1956
Excavations at Jarlshof, Shetland. Edinburgh: HMSO.

Hamilton, J R C 1968
Excavations at Clickhimin, Shetland. Edinburgh: HMSO.

Henderson, G & Henderson, I 2004
The Art of the Picts. London: Thames & Hudson.

Irvine, J T c1873
Orkney and Shetland Antiquities. Privately printed.

Johnstone, P 1980
The Sea-Craft of Prehistory. London: Routledge & Kegan Paul.

Lamb, R 1995
Papil, Picts and *papar*, in Crawford (ed) *Northern Isles Connections*, 9–27. Kirkwall: The Orkney Press.

Lang, J 1974
Hogback monuments in Scotland, *Proc Soc Antiq Scot* 105 (1972–4), 206–35.

Low, G 1879
A Tour through the Islands of Orkney and Shetland. Kirkwall.

Mack, A 2007
Symbols and Pictures: the Pictish Legacy in Stone. Brechin: The Pinkfoot Press.

Moar, P & Stewart, J 1944
Newly discovered sculptured stones from Papil, Shetland, *Proc Soc Antiq Scot* 78 (1943–4), 91–9.

O'Meadhra, U 1993
Viking-Age sketches and motif-pieces from the Northern Earldoms, in Batey, C E, Jesch, J & Morris, C D (eds) *The Viking Age in Caithness, Orkney and the North Atlantic*, 423–40. Edinburgh: Edinburgh University Press.

Owen, O & Lowe, C 1999
Kebister: the Four-thousand-year-old Story of one Shetland Township. Edinburgh: Society of Antiquaries of Scotland.

Ritchie, A 1997
The Picts in Shetland, in Henry, D (ed) *The worm, the germ and the thorn: Pictish and Related Studies presented to Isabel Henderson*, 35–46. Balgavies, Angus: The Pinkfoot Press.

Ritchie, A 2003
Paganism among the Picts and the conversion of Orkney, in Downes, J & Ritchie, A (eds) *Sea Change: Orkney and Northern Europe in the Later Iron Age AD 300–800*, 3–10. Balgavies, Angus: The Pinkfoot Press.

Ritchie, A 2008
A fragment of a Pictish symbol-bearing slab with carving in relief from Mail, Cunningsburgh, Shetland, *Proc Soc Antiq Scot* 138, 185–91.

Ritchie, A, Scott, I G & Gray, T E 2006
People of Early Scotland from contemporary images. Brechin: The Pinkfoot Press.

RCAHMS 1946
Royal Commission on the Ancient and Historical Monuments of Scotland *Inventory of Orkney and Shetland.* 3 vols. Edinburgh: HMSO.

RCAHMS 2007
In the Shadow of Bennachie: A Field Archaeology of Donside, Aberdeenshire. Edinburgh: RCAHMS/Society of Antiquaries of Scotland.

Scott, I G 1997
Illustrating early medieval carved stones, in Henry, D (ed) *The worm, the germ and the thorn: Pictish and Related Studies presented to Isabel Henderson*, 129–32. Balgavies, Angus: The Pinkfoot Press.

Scott, L G 1957
 The Islesburgh eagle, *Shetland Folk Book* 3, 51–2.

Sharples, N 1998
 Scalloway: a Broch, Late Iron Age Settlement and Medieval Cemetery in Shetland. Oxford: Oxbow Monograph 82.

SHC
 Shetland Historical Collections. 3 volumes compiled by J T Irvine.

Small, A, Thomas, A C & Wilson, D M 1973
 St Ninian's Isle and its Treasure. Aberdeen: Aberdeen University Press.

Smith, B 1995
 Scandinavian place-names in Shetland with a study of the district of Whiteness, in Crawford, B E (ed) *Scandinavian Settlement in Northern Britain*, 26–41. Leicester: Leicester University Press

Stevenson, R B K 1981
 Christian sculpture in Norse Shetland, *Froðskaparrit* 28/29, 283–92.

Thomas, A C 1971
 The Early Christian Archaeology of North Britain. Oxford: Oxford University Press.

Thomas, A C 1973
 Sculptured stones and crosses from St Ninian's Isle and Papil, in Small *et al* 1973, 8–44. Edinburgh: John Donald Publishers

Thomas, A C 1983
 The double shrine 'A' from St Ninian's Isle, Shetland, in Clarke, D V & O'Connor, A (eds) *From the Stone Age to the 'Forty-Five*, 285–92.

Turner, V E 1994
 The Mail stone: an incised Pictish figure from Mail, Cunningsburgh, Shetland, *Proc Soc Antiq Scot* 124, 315–25.

Turner, V E 1998
 Ancient Shetland. London: Batsford/Historic Scotland.

Index

Page references in *italic* refer to illustrations

Aith Voe, Cunningsburgh, Dunrossness, runic inscriptions (nos 73, 74) 1, *34*
axe 4

Baliasta, Unst, recumbent monument (no.127) v, vii, 9, *44*, 54
bear v, 2, 8, *14*, *28*
Belmont, Unst, Norse house vii
bird 3, *15*
birdmen 4
boar 2, *14*
board games 3
book satchels 4, 8, 10, *18*, *19*, *28*
Book of Durrow 4
Breck of Hillwell, Dunrossness, symbol stone (no.2) v, 1, 2, *12*, 47
Breckon, Yell, footprint stone 2
Bressay, Lerwick, runes (nos 79, 80) 8, *35*, 51
brochs 1, 2, 7
Burn of Noss, Scousburgh, Dunrossness, carved stone disc (no.20) *16*, 48
Burra Stone *see* Papil, West Burra, cross-slab (no.29)

Cerberus 4
Christian amulet 3
Christian imagery 4, 5
Christianity v–vi, vii, 3, 4, 6
church
 buildings vi, vii, 5
 dedications vi, 8
Clickhimin, Lerwick, footprints stone (no.10) 2, *14*, 47
Coppister, Yell, cruciform stone (no.84) *36*, 52
corner posts (nos 31–39, 41–47) 4–6, *18–25*, 49
Cross Kirk, Esha Ness, runic inscription (no.77) 8, *35*, 51

cross-slabs vi, vii, 4, 8, 18, *29–33*, 50–1
 incised (nos 66–72) *32–3*, 51
 outline (nos 55–60) *29–30*, 50
 relief (nos 117, 124, 125, 128) *41*, *43*, *44*, 54
 sunken (nos 61–5) *30–2*, 50
cruciform stones (nos 81–123) vii, 8–9, *36–43*, 51–3
Culbinsburgh, Bressay, Lerwick
 cross-slab and ogham (no.54) vi, vii, 6, 7–8, 10, *28*, 50
Culbinsgarth/Cullingsburgh, Bressay *see* Culbinsburgh, Bressay

discs, carved stone (nos 16–28) v, 3, 4, 10, *16–17*, 48
Dockrill, Steve 2
Dunadd, Argyll, footprint stone 2

eagle 10
Eswick, Nesting, carved stone disc (no.21) *16*, 48

Fair Isle, Dunrossness vi
figurines
 Mail, Cunningsburgh, Dunrossness (no.14) 1, 3, *15*, 48
 Northmavine, Delting (no.13) 3, *15*, 48
 Scalloway, Tingwall (no.15) 1, 3, *15*, 48
fish 2, 10, *14*
footprints 2, *14*, 47
'formidable man', Mail, Cunningsburgh, Dunrossness (no.6) v, 1, 3, 4, 10, *14*, 47
Forsyth, Katherine 6, 7
Framgord, Sandwick, Unst
 church vii
 cruciform stones (nos 115–119) *41–2*, 53
 Norse houses vii
 recumbent gravestone (no.128) vii, 9, *10*, *44*, 54
 relief cross (no.126) *43*, 54

Index

Gaelic language vi, vii, 6, 7
genii cucullati 3
Gletness, Nesting, carved stone disc (no.22) 3, *16*
Goudie, Gilbert 7
graffiti vi–viii, 3, 8
Gungstie, Noss, Lerwick vi
 corner post (no.46) 5, *25*, 49
 cross-slabs (nos 63, 67) *31*, 50, 51
 runic graffito (no.78) 8, *35*, 51

Hamar, Unst, Norse house vii
hogback monument (no.126) vii, 9, *44*, 54
horses 5, 7, *28*
Houll, North Roe, cruciform stones (nos 82, 83) *36*, 51

inscriptions
 ogham (nos 48–53) 6–7, *26–7*, 49–50
 possible 4
 runic vii, *34–5*, 51
Iona, Argyll vi, 3, 4, 8
Isle of Man, Viking-age carved stones 9
Islesburgh, Northmaven, carved stone (no.131) 10, *45*, 54
Ireland, Dunrossness, steeple kirk vi
Ireland, cruciform stones 9

Jarlshof, Sumburgh, Dunrossness
 carved stone (no.129) 9, *45*, 54
 discs (nos 16–19, 23, 25, 27) v, 3, 4, 10, *16–17*, 48
 graffiti vi–vii, 3, 8, 9
 runes 8
 settlement v, vii, 2, 4

Kebister, Lerwick, cross-incised pebble (no.12) 2–3, *15*, 48
keeled stones vii, 9
Kirkhouse, South Whiteness
 cross-slabs (nos 57, 58, 60) 8, *29*, *30*, 50
 key-pattern fragment (no.58) 8, *30*, 50
 ogham (no.49) 6–7, *27*, 50
Kirk of Gloup, Yell, cross-slab (no.65) *32*, 50

'Lerwick Museum', carved stone (no.3) 1, *13*, 47, 54
'Lerwick Museum', carved stone disc (no.28) *17*, 48, 54
lion 4, 8, *28*
Lion of St Mark 4
lost carved stones (nos 1, 65, 107–9) 1, 2, 7, 11, *32*, *38–9*, 47, 50, 53
Low, George v
low relief carving 4

Lundawick, Unst
 carved stone (no.130) 10, *45*, 54
 cruciform stones (nos 103–9) *39–40*, 52–3
 relief cross (no.124) *43*, 54
Lunnasting, ogham (no.52) 6, 7, *27*, 50

Mail, Cunningsburgh, Dunrossness v
 chapel, possible 1
 figurine (no.14) 1. 3, *15*, 48
 'formidable man' (no.6) v, 1, *3*, 4, 10, *12*, 47
 Pictish carved stones (nos 5, 6) v–vi, 1, *3*, 4, *13*, 47
 ogham inscriptions (nos 50, 51, 53) 1, 6, 7, *27*, 50
 runic inscription (no.76) 1, *34*, 51
monks 4, 7–8, *18*, *19*, 28

National Museums Scotland, Edinburgh v, 7
Ness of Burgi, Dunrossness, carved stone disc (no.26) *17*, 48
Ness, Tankerness, Orkney carved stone 9
Norse period 8
 art style 9
 axe, South Whiteness 8
 churches, sites of 9
 houses vii
 influence vi–vii, 1–2, 7
 language vi, vii, 8
 runic inscriptions vii, 8, *34–5*, 51
North Kirk Geo, Yell, cruciform stones (nos 85–92) *36–7*, 52
Northmavine (Northmaven), Delting, bird figurine (no.13) 3, *15*, 48
Norway, cruciform stones vii, 9, 10
Norwick, Unst, cruciform stones (nos 110–113) *9*, *40–1*, 53

ogham inscriptions (nos 48–54) vi, 6–7, *26–8*, 49–50
Old Scatness, Dunrossness
 graffiti (no.11) vii, 2, *15*, 47
 Pictish carved stones (nos 7, 8, 9, 11) 2, *14–15*, 47
 settlement 2

pagan religion iv, 3, 10
painted pebbles v
Papil, Yell, possible location for carved stone (no.3) 1, 47
Papil, West Burra, Lerwick vi, 10
 Burra Stone, cross-slab (no.29) vi, *3*, 4, 5, 10, *18*, 48
 corner-posts (nos 36, 38–43) 4–5, *22*, *23*, *24*, 49
 cross-slab (no.59) 8, *30*, 50
 Monks Stone, shrine panel (no.30) 5, *19*, 48
 runic inscription (no.75) *34*, 51
 steeple kirk vi

Pictish
 houses v
 language vii
 symbols v–vi, 1, 2, 3, 4, 10, *12–14*, *15*, 47–8
Pictish symbol-bearing cross-slabs 10
 possible (nos 3, 4, 5) 1–2
pig 8, 28
place-names vi, 1, 4, 7, 8
porpoise 3

Reafirth, Yell, cruciform stones (nos 98–101) *38–9*, 52
recumbent gravestones (nos 127, 128) v, 9, *44*, 54
relief crosses (nos 125, 126) 9, *41*, *43*, *44*, 54
reliquaries 4, 5
runic inscriptions (nos 73–80) vii, 8, 11, *34–5*, 51

St Andrews, Fife vi
St Laurence's Kirk, West Burra, Lerwick 4
St Luke's Chapel, Kildrummy, Aberdeenshire 9
St Mary's Kirk, Culbinsburgh, Bressay 8
St Mary's Kirk, Burwick, South Ronaldsay, Orkney, footprints stone 2
St Magnus Church, Egilsay, Orkney, steeple kirk vi
St Ninian's Isle, Dunrossness v
 chapel vii, 5
 corner-posts (nos 31–35, 37, 44, 45, 47) 3, *6*, *19–25*, 49
 cross-slabs (nos 55, 56, 61, 62, 66, 68–72) vii, 6, *8*, *29*, 50–1
 cruciform stone (no.81) *36*, 51
 hogback (no.126) vii, 9, *44*, 54
 ogham (no.48) 6, 7, *27*, 49
 panel, possible (no.40) 5, *22*, 49
 shrines vi, 4–6
 silver treasure vii, 3, 6, 10
St Ola's Kirk, Whiteness *see* Kirkhouse, South Whiteness
Sandness, Walls, symbol stone (no.1) v, 1, 2, *12*, 47
sandstone vi, 3
Sandwick, Unst, Norse house vii
Scalloway, Tingwall, figurine (no.15) iv, 1, 3, *15*, 48
schist vi
seal 3
Shetland Museum v, 9
Shetland pony 5
shrines, stone box 3–6, 10
 corner posts (nos 31–39, 41–47) *18–25*, 49
 panels (nos 30, 40) 5, *19*, *23*, 48–9
 reconstruction 5, *18*
Skaill, Deerness, Orkney, interlaced cross 4
South Garth, Yell, carved stone 10

South Whiteness *see* Kirkhouse, South Whiteness
spiral ornament 3, 5, 6, *19–24*
steatite vi, 3
steeple kirks vi, 4

Tarbat, Easter Ross vi
Thomas, Charles 5
Tingwall Kirk, Tingwall, steeple kirk vi
Tresta, Fetlar, Unst, cruciform stones (nos 120, 121) vi, *42*, *53*

Ulsta, Yell, cruciform stone (no.93) *37*, 52
Underhoull, Unst, Norse house vii
Uyea, Unst
 cruciform stones (nos 122, 123) *43*, *53*
 possible symbol stone (no.4) 1, *13*, 47

votive objects iv, 1, 3

West Sandwick, Yell, cruciform stones (nos 94–7) *38*, 52